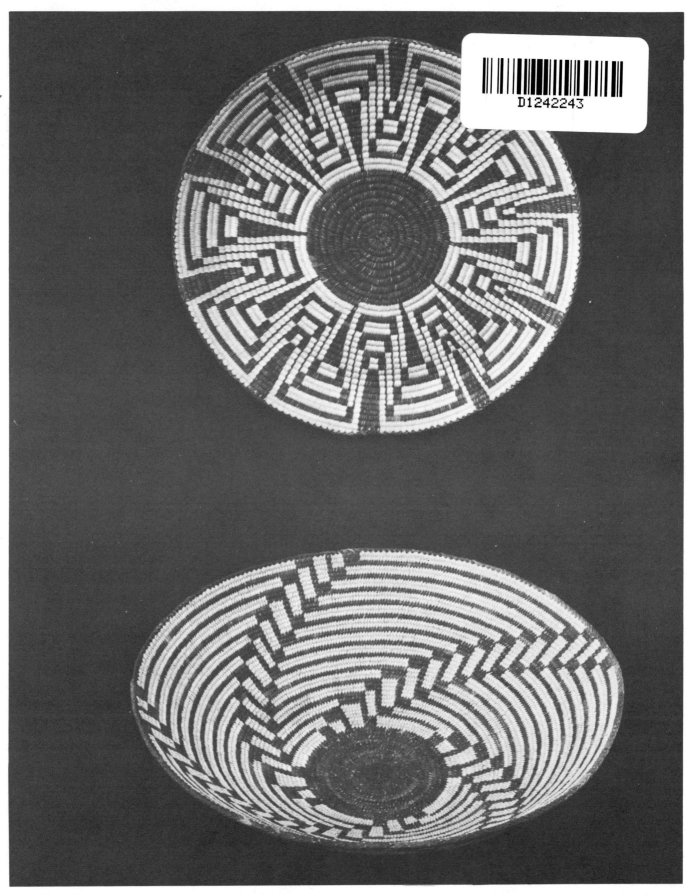

Pima baskets, close-coiled shallow bowl types, c. about 1930. Heard
Museum Collection, photo courtesy Heard Museum.

BASKETRY OF THE PAPAGO AND PIMA.

The famed Heard Museum, 22 E. Monte Vista Rd., Phoenix, Ariz., 85004, houses one of the country's greatest collections of aboriginal and contemporary Indian basketry. Its collection of Papago and Pima baskets, like those pictured on the endpapers of this book, spans the products of many generations and is considered to be the finest collection in existence.

BASKETRY
of the
PAPAGO and PIMA
INDIANS

Mary Lois Kissell 643

The Rio Grande Press, Inc.

GLORIETA, NEW MEXICO · 87535

ⓒ 1972, The Rio Grande Press, Inc.,
Glorieta, N. M. 87535

Library of Congress Cataloging in Publication Data

Kissell, Mary Lois.
 Basketry of the Papago and Pima Indians.

 (A Rio Grande classic, 86)
 Reprint of the 1916 ed., which was issued as no. 17,
pt. 4 of Anthropological papers of the American Museum
of Natural History.
 1. Papago Indians--Industries. 2. Pima Indians--
Industries. 3. Indians of North America--Basket making.
I. Title. II. Series: American Museum of Natural
History, New York. Anthropological papers, v. 17, pt. 4.
E99.P25K58 1972 746.4'1 72-8827
ISBN 0-87380-095-8

A RIO GRANDE CLASSIC
First published in 1916

Anthropological Papers of the
American Museum of Natural History
Vol. XVII, Part IV

Third Printing 1982

The Rio Grande Press, Inc.
GLORIETA, NEW MEXICO · 87535

Publisher's Preface

The Rio Grande Press has reprinted a number of titles pertaining to the culture, arts and crafts of the American Indian, of which the best known and one of the most popular is Otis Tufton Mason's monumental study entitled *Aboriginal American (Indian) Basketry*. The art of aboriginal basketry has flourished since prehistoric times, suffering a real decline between, say, 1935 and 1960, but it appears now to be coming back in a most interesting and artistic fashion.

The Papago and the Pima tribes are located on the Pacific coastal desert of southwestern United States and northwestern Mexico. The habitat of the Papago (Papagueria) occupies the southern portion of the area, and extends from the Gila River southward over a considerable part of southwestern Arizona and Sonora. The habitat of the northern group, the Pima, lies to the north of Papagueria in the valleys of the Gila and Salt Rivers, in Arizona. The Pima habitat is much smaller in extent than Papagueria and its villages are much more closely grouped. Both the Papago and the Pima Indians are living as tribal units today.

Nowadays, one can find contemporary Papago and Pima basketware for sale all over the American Southwest, made in the same way, of the same materials and to the same designs as those made decades ago. Basketmaking art has revived and is going "great guns," and it is no different now than it ever was; for that reason, we have made no changes anywhere in the book.

It should be noted that this paper was originally published as part of a larger volume, with 112 pages (or more) preceding this paper, and pages succeeding folio 264. All we had to work from were these pages only. We have not changed the pagination sequence; to do so would disturb the many bibliographic citations to a certain page, figure or plate in the literature of the subject. Hence, our edition is paginated exactly the same as the first edition.

We have, however, photographically enlarged the page size in reproduction from its orginal 6¼ inches by 9¼ inches to 8½ inches by 11 inches. We did this both to enhance the artwork and increase the type size, and to conform this title to the same dimensions as all of our other titles on Indian arts and crafts. Those of our readers on the downhill side of 40, like ourselves, appreciate the larger type and art detail. Some do not like it when we enlarge a book, but we learned long ago that we cannot please everyone.

For a note about author Mary Lois Kissell, we sought the assistance of the New Mexico State Library, the Santa Fe Public Library, the personnel office of the faculty of the University of California at Berkeley, the Library of Congress reference desk, the Arizona Historical Society, and others, but the entire extent of the information we were able to develop consists of the entry

in the 1914–1915 edition of *Who's Who in America*. Subsequent editions through the 1940–1941 edition refer back to the 1914–1915 edition only. Her name is not listed in the 1942–1943 edition or subsequently. The cited entry reads:

Born Davenport, Ia; daughter of Abraham S. and Mary Augusta (Scofield) K.; B. S., Columbia, 1911. A. M. 1913, Art Inst. Chicago; research work in museums of Europe; served as instr. in Art Inst., Chicago; U. of Chicago; Columbia U.; with Am. Mus. Natural History, New York, 1906–1911; asso. prof. domestic art, U. of Cal., July 1, 1912–. Fellow A.A.A.S. Collector and explorer among Am. Indians. Wrote (brochure) Aboriginal Weaving in America; articles in "Science" and "American Anthropologist." Address: University of California, Berkeley, Calif.

This is the 88th title we have published, and the 86th beautiful Rio Grande Classic. The other two titles we call Rio Grande Press Pictorial Specials.

We note in passing that author Kissell cites *New Trails in Mexico*, by Dr. Carl Lumholtz, as a source regarding the ethnology of the Papago and Pima Indians. That title was first published in 1912; we reprinted it in 1972.

In our previous (1974) edition of this title, we had no artwork on the endpapers; this time, thanks to the cooperation of the famed Heard Museum in Phoenix, Az., and director Michael Fox, we have a photograph of the Museum on the frontispiece facing our title page, and on the endpapers two photographs of Papago and Pima baskets from the magnificent Heard Museum collection. And following our words here, we have a splendid Introduction to this book by Curator of Collections Ann E. Marshall, who holds a master's degree in Anthropology from the University of Arizona in Tucson. We are honored, and we greatly appreciate the cooperation extended us by Mr. Fox and Ms. Marshall and the staff at the Heard Museum.

Robert B. McCoy

La Casa Escuela
Glorieta, N. M., 87535
January, 1982

Introduction

Mary Lois Kissell studied Papago and Pima basket making in Southern Arizona during the winter of 1910–1911. Her work, *Basketry of the Papago and Pima Indians*, was published in 1916 as part of the Anthropological Papers of the American Museum of Natural History. Although other scholars, particularly Frank Russell, had written about the Pima or Papago, Kissell's work was the first to focus on the wide range of basketry made and used by these two groups.

Kissell's work documents a changing time for Papago and Pima basketmakers. Arizona was little more than a year away from statehood, and the railroads were bringing increasing numbers of people and manufactured goods to the West. Within Pima and Papago communities, metal containers were available to replace basketry bowls, canvas covers and cloth sacks could replace plaited basketry mats, and horses and wagons could carry more than a woven net burden basket. However, because change had been rather recent, in 1910–1911 Kissell was able to talk with many people who remembered old methods of collecting and preparing basketry materials and who still made a wide range of basketry for use in their own homes and villages. Kissell was particularly successful in more remote Papago villages where change was coming more slowly.

While most of Kissell's work documents basketry made for use within Papago and Pima communities, she also comments on the changes in basket-making caused by tourists and traders. Tourists wanted smaller baskets with shapes they could use in their homes. They also wanted baskets decorated with recognizable life forms, such as a lizard or a cactus, or at least decorated with a design that had a name. Kissell found that older basketmakers sometimes had no name for their designs while younger women, accustomed to working with traders and tourists, had developed names for their designs.

Kissell was interested in basketry techniques in their broadest sense. She does not limit her discussion to woven containers but discusses and illustrates basketry techniques used to make house walls and doors, animal cages and coops, and hairbrushes. Her discussion of plaited medicine baskets also includes information on the contents of each basket and the use of these various materials in ceremonies.

Kissell supplemented her text with interesting photographs taken in the field. Her photographs show women making and using baskets. They supply a great deal of information about house construction and dress styles. The photo series showing a full burden basket being lifted is fascinating.

The most dated part of Kissell's work relates to her theories of culture. The section, "Reflection of Personal Traits," places Kissell's work at a time

sixty-five years ago when some anthropologists were attempting to talk about whole groups of people using psychological terms that were usually applied to an individual. Kissell attempted to show how these personality traits were translated into basketry. This simplistic attempt at culture analysis was abandoned by anthropologists many years ago along with an evolutionary approach that characterized some groups of people as representative of "low cultures." The reader simply has to bear in mind that when Kissell did her work in 1910, anthropology was a very new science.

Kissell's work provides a very comprehensive and clear discussion of Papago basketry to 1911. Those familiar with Papago basketry made of yucca will find that much of Kissell's work was done before yucca close coil basketry was common. Certainly the newest Papago split stitch technique had not been thought of in 1910.

This edition of Mary Lois Kissell's *Basketry of the Papago and Pima Indians* retains the same pagination as the original printing which was published as Part IV, Volume XVIII in the Anthropological Papers of the American Museum of Natural History in 1916. The pagination has been left unchanged in order to maintain a correlation between internal references and the plates and figures to which they refer.

<div style="text-align: right">

Ann E. Marshall
Curator of Collections

</div>

The Heard Museum
Phoenix, Arizona
January, 1982

ANTHROPOLOGICAL PAPERS
OF
THE AMERICAN MUSEUM
OF NATURAL HISTORY

VOL. XVII, PART IV

BASKETRY OF THE PAPAGO AND PIMA

BY

MARY LOIS KISSELL

NEW YORK
PUBLISHED BY ORDER OF THE TRUSTEES
1916

BASKETRY OF THE PAPAGO AND PIMA.

By Mary Lois Kissell.

LITHO BY INTER-COLLEGIATE PRESS, SHAWNEE MISSION, KS

PREFACE.

The investigation herein reported was made during the winter months of 1910–1911 in some two dozen Pima and Papago villages, as a part of the Museum's systematic study of the peoples of lower culture in southwestern United States. All the principal villages of the Santa Rosa Valley and foothills were visited, together with those of the Santa Cruz near Tucson, including San Xavier, Kioto, Little Tucson, Indian Oasis, Big Fields, Cababi, Comababi, Vinumuku, Conquien, Quijotoa, Kuvuhea (Chewak), Twavaheu, Brownell Camp, and Noepa; as well as the Pima villages of Kuu Ki, Hassanykuk, Saopuk, Talsituk, Oskuk, Wetcurt, Rsotuk, Hermho or Amn Akimult, and Babychurl. Acknowledgment must be made for the identification of the plants employed in basketry to the staff of the botanical department of the University of Arizona; and for very courteous hospitality to Rev. and Mrs. Herndon, Indian Oasis; Mr. Day, Quijotoa; Mr. Brownell, Brownell Camp; and Mr. R. Rasmessen, Tuscon. For the drawings the author is indebted to Miss Ruth B. Howe and for the photographs of specimens to the Photographic Department of the Museum, for that of the Papago granary to the United States National Museum, and the basket maker within her storage bin to Putnam and Valentine, Los Angeles. The outdoor photographs were taken by the author, often under very adverse conditions, but the subjects presented are in the main new. The expenses of the field trip were contributed by Mr. Archer M. Huntington.

April, 1916.

CONTENTS.

ILLUSTRATIONS.

TEXT FIGURES.

INTRODUCTION.

This paper presents material obtained during three months of research in southern Arizona among the Pima-speaking tribes — the Papago and Pima proper — and records some of the results of an intensive study of their textile arts. Dr. Russell's comprehensive treatise on "The Pima Indians," and Dr. Lumholtz's "New Trails in Mexico" give a general survey of the ethnology of these two tribes. It is the purpose of the present paper to deal solely with their basketry, since there are important points related to this art heretofore undiscussed; and to include descriptive matter pertaining to technical details of present-day processes, with reports of former methods now abandoned, but still within the memory of the tribes; beside explanatory matter concerned with conclusions drawn from this information and from observation. Technic of itself has only economic value, its scientific significance lies in its bearing upon some theory, or problem, that is in the disclosing of some hidden truth.

The aim of the expedition was not only to obtain exact details as to the processes and the materials employed in this art, but also to procure the more interesting and important data concerning beliefs, sayings, and magic connected with the art or its processes. In other words, to find all the lore pertaining to the textile arts especially that of the basketry, should there be any, and still be known to the present-day Indian. This together with information concerning symbolism in design, constituted the two points of greatest importance.

As is frequently the case in field investigation, the data most earnestly desired may prove elusive and not materialize, while in its place other data are secured bearing on totally different lines. So it proved in this instance, that while full details as to the processes, tools and materials, together with interesting related facts, were easily obtained, the two topics believed to be of greatest moment yielded scanty results. This may be attributed to one of two causes: either to the absence of basketry lore because it had been forgotten, or had never existed; or to the very brief acquaintance with individual Indians, which was all the short trip afforded, as the three and a half months allotted to more than twenty scattered villages were insufficient for other than casual friendships. Longer acquaintance might have established an intimacy with individuals, such as would invite confidences and disclosures of sacred lore. It is hoped that later investigations, especially among the very old women, will unearth such data if they exist.

As has been said, religious meaning attached to basket materials, their

gathering, preparation, or employment in construction seems entirely wanting. The art appears to be purely a practical one, prompted by practical motives only. This is not absolutely so, however, in connection with the use of three of their baskets — the small food basket of the medicineman, the basket drum, and the rectangular trunk shape for holding ceremonial medicines and paints. This last is made only by the Papago, and employed exclusively for this purpose, while its size is carefully fitted to hold some specific medicine. The basket appears to have no ceremonial significance in itself, its function seems to be purely utilitarian, that of holding the ceremonial articles when not in use. The food basket in question is a deep tray of small circumference, so closely constructed as to hold water, and is used by the medicineman to hold food and drink while he is performing the ceremonies for healing the sick, for bringing rain, and when on his pilgrimages for the sacred salt. It is made for this purpose and used at no other time, but whether its function was more than utilitarian, knowledge was not obtained. The basket drum is also a tray shape, but it is not constructed for this particular use, nor is it reserved for this exclusive service. Any basketry tray at hand will do, if it is hard and firm enough in build to emit a loud sound when inverted and struck with the hand or a stick, since the beating upon it accompanies the chants of the medicineman at ceremonial dances, or when making his cures. The basket tray of these peoples is a food tray, and whether for this reason there is in it some magic which imparts efficacy to the rhythmic accompaniment is not known. It is more probable that it is merely a convenient thing upon which to beat, hard enough to resound when struck.

The most important result of the expedition was the finding of a distinct differentiation between the Papago and Pima coiled basketry, a technic to the perfection and decoration of which these tribes have devoted their leisure time and effort. Such a technic in any tribe acquires the highest development of the arts belonging to that particular people, thus receiving the impress of a character of its own. Here the coiled basketry of these linguistically related tribes was found to have such distinguishing and diverse qualities as to make apparent that the art in each tribe was distinct. This discovery gave the incentive to secure as many as possible of the few remaining old-time water-tight bucket-baskets of the Papago. This was done, resulting in a collection, which with two old basket bowls from the Lumholtz expedition of the previous year, make this small but choice group of old Papago coiled ware, not only unique, but rare, since very few of these baskets remain, owing to the influx of civilization and the Papago custom of burning at death all the belongings of the deceased.

Only the beginning of a very interesting study of the differences in

Papago and Pima coiled ware has been made, an investigation which has every appearance of being an important one, since the facts gathered show this cultural difference in the tribes and possibly point, as suggested by Dr. Fewkes, who has examined the results of the expedition, to a further discovery that the Papago are related to the old prehistoric people of the area. Further research, especially in the unfrequented villages in the foothills of the Quijotoa, Comobabi, Baboquivari and neighboring ranges, will no doubt throw additional light on the age of coiled basketry, its design names, and the old design itself, for frequently direct design study yields more satisfactory results than dependence upon Indian report.

These differences have every appearance of being a direct result of personal characteristics, for the individual traits of the tribes seem stamped upon the baskets of each. Papago baskets with solid substantial qualities resemble dominant Papago peculiarities; Pima baskets with lighter more pliable properties represent the Pima temperament. Some of these dissimilarities are due to the materials employed in manufacture and some are a result of function, thus accounting for certain structural diversities, namely, flexibility and solidity, beside general items of shape. But these utilitarian agencies give no satisfactory interpretation to divergence in design, or the finer subtler qualities in proportion, contour, build, and finish.

Reaching backward into the past to interpret the art of the coiled basketry in times gone by, reveals interesting data as to habits and methods, but the present also offers data for record, since Papago and Pima basketry means to the world today the art as it is now being practised. An important contribution to the subject, therefore, is a registry of present-day practice, as influenced by the influx of civilization, since each tribe has responded to this impelling agency, but in different ways.

The basketry of these desert tribes illustrates, in an individual way, the relation between the arts of people of lower culture and their environment. On this account, and to facilitate comparison, their habitat and its vegetation have been described at some length, for as plant life has become structurally modified to harmonize with surrounding arid conditions, so basketry construction, through man's instrumentality, has in a similar manner been adjusted to the desert flora. Suitable material for a number of common basket technics is lacking, and so excludes these; available material for those that are present, is in such limited quantities as to demand the exercise of much skill in discovery, selection, and adaptation. As would be expected, these technics show a most interesting interrelation with desert materials, which on account of the general distribution of the same plants throughout the area, furnish both tribes with certain similar technics; and owing to the location of other materials in the habitat of but one tribe, supply each

with a different technic; while because of a slight differentiation in the materials employed on a similar technic, distinct characteristics are given to each.

Of the technical points introduced, perhaps the most valuable is the suggestion of a possible evolution of two technics in the region — wrapped and lattice wrapped weaving, and foundation coiling. Another important item is the presence of the plaited center on coiled basketry which suggests that plaiting was here an earlier technic than foundation coiling. Considerable effort was expended in obtaining the rhythmic movement in the construction of plaiting, a movement which is always in threes, as it was thought this might prove an interesting likeness, or difference, to the rhythmic movement on plaiting among other tribes, and also give some further knowledge as to development of counting, or number, among people of lower culture. Detail in the technic of lace coiling seemed of value because of the elaborateness in pattern on the kiaha carrying frame which is fast passing into disuse. To make clear any technical terminology which might be misunderstood, the basketry classification made by the writer in 1909, and which this paper follows, is added as an appendix. (See *Science*, n. s. vol. 30, Dec. 24, 1909.)

HABITAT.

The Papago and the Pima tribes are located on the Pacific coastal desert of southwestern United States and northwestern Mexico. The habitat of the Papago, Papagueria, occupies the southern portion of the area, and extends from the Gila River southward over a considerable part of southwestern Arizona and of Sonora. The region is an undulating plain with an elevation, at its greatest height, of about three thousand feet, from which it inclines gradually toward the west. The territory is crossed by broken mountain ranges extending north and south, whose slopes have been greatly reduced, mainly by wind erosion, which has swept the soil into the flat valleys between. In Arizona, these valleys are dry, except that of the Santa Cruz which is drained by a characteristic desert stream. This river has a flow of great volume in the rainy season, but one so inconsiderable during most of the year that it might aptly be termed a brook. To the west and south of the Santa Cruz Valley is that of the Santa Rosa, long and narrow in shape and, as has been indicated, of the dry type. Through it, in all probability, there once flowed a great river which is now covered with soil from the mountains on either side. This is the very center of the Papago country, for in the foothills of the Quijotoa and Comobabi mountains, which border the Santa Rosa Valley, and the neighboring Baboquivari Range, are scattered many of the Papago villages. Possibly in no other spot in North America has the Indian been less influenced by white men, so that old customs persist, even to the tattooing of the face by the older men and women. It was the villages of the Santa Rosa Valley and foothills, together with those of the Santa Cruz near Tucson, which were visited by the expedition, including San Xavier, Kioto, Little Tucson, Indian Oasis, Big Fields, Cababi, Comobabi, Vinumuku, Conquien, Quijotoa, Kuvuhea (Chewak), Twavaheu, Brownell Camp, and Noepa.

Many of the permanent villages are located in the foothills, where there is better grazing ground for the herds and water can be reached by sinking wells to the depth of from twelve to forty feet, while in the valleys it is estimated that water cannot be reached short of two hundred feet. Nevertheless, it is in the flat, dry valleys that the villagers plant their fields, since the Papago primarily are agriculturists, although they also obtain wild food, both vegetal and animal. The water supply for the fields is furnished by the scant rainfall, and by surface water which collects during the rainy season in a few water holes. From these, it is distributed by means of irrigation ditches. At the planting and harvesting season, the villagers move down into the valley, and usually remain there until the water holes

are empty. Upon quitting the fields for the foothills, they station a few of their number to act as watchers, who care for the crops. This seasonal migration between foothills and valley means a change of habitation four times during the twelve months, owing to the fact that there are two crops annually. The frequent moving, however, does not seem to disturb the Papago Indian in the least, for with apparent ease he loads his wife, children and household effects upon a couple of horses, or burros, and starts off, himself on foot. These beasts of burden, almost hidden beneath bundles, baskets, pots, women and children, are not unusual sights as they follow some lonely trail across the desert. When the migration will take place is uncertain, since weather conditions are so changeable. So it often occurs that one reaches a village in the foothills at a season when one would expect the Indians to be there, to find most of the huts barricaded and many of the people gone to the fields; or one reaches the fields in the valley, to find they have departed for their homes in the foothills, since the varying atmospheric conditions of the desert require a similar adjustment of domestic affairs to fit the requirements of the crops.

These arid valleys only need water to make them fertile gardens, for even with the limited supply at hand the soil yields two crops annually. Wheat, maize, beans, pumpkins, squashes, and melons are most cultivated. The seasons for planting and for harvesting must, of course, vary with the irregularity of climatic conditions, so that wheat is sown sometime between October and Christmas, and gathered about May; corn is planted in the neighborhood of the first of August, and harvested sometime in October. Formerly, the men cleared, planted, and irrigated the fields while the women gathered all the crops with the exception of the wheat. This was transported by the men on horses, whereas the women carried the other products in their kiahas, or carrying baskets on their backs. Woman's labor in the field has been greatly lightened by the introduction of a few modern conveniences, notably that of the wagon. However, when her help is needed, she is seen in the fields performing her old duties as well as those of the man.

The habitat of the northern group, the Pima, lies to the north of Papagueria, in two river valleys, the Gila and the Salt. These rivers during the rainy season are rushing torrents, but through most of the year their beds are entirely dry. Nevertheless, even these fluctuating streams have drawn the Pima villages to their banks, since water, one of the greatest necessities to human life in any climate and doubly needful in an arid land, has attracted the Indians to the neighborhood of its supply. The Pima habitat is much smaller in extent than Papagueria, and its villages are much more closely grouped. Those visited at this time were Kuu Ki, Hassanykuk, Saopuk, Talsituk, Oskuk, Wetcurt, Rsotuk, Hermho or Amn Akimult, and Babychurl.

Like the Papago, the Pima subsist upon both animal and vegetal food, although mostly upon the latter, and usually upon that which is cultivated. Their fields are not at a distance as are those of the Papago, but adjoin the villages, or are in the near neighborhood; thus migration between village and field as practised by the Papago Indian is not necessary. The water supply for the fields was formerly furnished by the rivers, but now that the white man is making use of the headwaters of these streams, and diverting a considerable supply, it has become necessary for the Pima to depend more and more upon wells. The fields have suffered greatly from this use of well-water, and are in a much poorer condition than when they could depend entirely upon the rain and the river-water, since the well-water is alkaline in character, and also lacks the enriching sediment which is brought down by the rivers. The products raised by the Pima and their methods of planting, harvesting, and transporting are similar to those of the Papago, although here customs of civilization have entered more largely. The seasons are slightly later than in Papagueria: wheat is sown in April, and reaped in June; a first crop of corn is planted in April and gathered in June, while a second crop of corn is planted in July, and harvested in October.

The desert home of these tribes is one of the most interesting spots on the American continent. Its lonely stretches, even in its most desolated parts, are not entirely without vegetal life, for it is thinly scattered over with stunted trees, hardy bushes, and prickly cactus plants. A cursory glance at the parched plant life and the baked earth makes it difficult to realize that only dearth of rainfall makes this region what it is, and that a supply of water would bring blossom and fruit in profusion, where now desolation spreads over much of its extent. Yet, it is the very desolation of these vast stretches, their immensity, and their impressive solitude which charm and fascinate. The broken mountain ranges rise abruptly from the plain. Their highest ridges are sparsely clothed with unexpected pines and oaks, for in consequence of their altitude the peaks receive an annual rainfall of thirty or more inches. With the lower mountains it is quite different, their leaden sun-baked slopes are mostly barren rock. The foothills show another change, as they again take on a vegetation, but one which is characteristic of the desert, with many strange spiny plants. In the valleys another vegetation appears, the typical plant life of the desert gives way to a vegetation with softer foliage, a direct result of more moisture. The scattered willows and cottonwoods along the river banks are examples of this. The valleys in Papagueria are usually long and trough shaped, flanked on either side by mountains, while those in the Pima country are more circular, and frequently surrounded on all sides by mountains.

This desert area with its low ranges and flat valleys is a land of sunshine.

One is impressed on entering the region of the dearth of everything save sunshine, for it is the dominant note. The summer sun pours down its pitiless rays, resulting in baked mountains, arid valleys, and parched vegetation. The winter sun, although less hot, continues to shine one day after another, with scarcely a cloud to mar the sunshine, and only a few rainy days in the wet seasons. It is during the short wet seasons of midsummer and midwinter that most of the rain is precipitated, and then the fall is only slight, except upon the highest ranges. Frequently there are years when there are no wet seasons, then the whole area suffers from drought, sometimes eighteen months pass without a drop of rain. In this dry land the sun has left its imprint everywhere and upon everything. Its intense heat has not only taken up every particle of moisture from the land, but from the air as well, leaving it remarkably light and clear. This clearness brings remote objects very near, greatly disturbing and preventing correct calculation of distances. It plays innumerable atmospheric tricks in this way, painting in the air at early morning and evening wonderful mirages of mountains and lakes, whose deceptive forms have frequently led many a weary traveler from his way, with disastrous results.

As has been said, the slight rainfall, the intense heat, and excessive evaporation have most perceptibly affected the vegetation of the area. All plant life has protected itself against the severe climate in most interesting ways, but with typical desert vegetation the adjustment is the most extreme, so that accordingly plant life has assumed shapes and structures particularly adapted to these adverse conditions. Some plants have enlarged their leaves and stems into thick pulpy forms, to act as absorbers of moisture and as storage reservoirs. An excessive amount of water can be collected in these thick forms during the rainy seasons, to serve as a supply for the plant during the periods of drought. Noticeable instances of these oddly transformed plants are the giant cactus saguara with its high fluted columns, at times rising forty or fifty feet in the air; the prickly pear with queer flat-oval jointed stems; and the melon or barrel cactus, which in its larger varieties, holds from six to eight gallons of water. This last cactus is most useful in this particular, as the water stored within it, has many times saved the life of man and of beast. Plants with enlarged stems are more fantastic in shape than those with enlarged leaves, yet these last are unusual, with their long leaves which encircle the central stem very much thickened for the storage of extra sap. Among these are the agave, or century plant, with spiked leaves of great weight; the palmea with narrower sword-like leaf, edged with saw teeth; and the yucca of similar shape, but with knife-like edged leaf.

Plant protection is not only accomplished by the storage of water, but

also by the preventative means taken for lessening evaporation. This is effected by diminishing the exposed leaf surface, and by coating the leaf and the stem. For decreasing the leaf surface, trees and shrubs may reduce the leaf to a very small size; they may transform them into spines or thorns; or they may dispense with the leaf altogether, when nothing remains but a bramble of stems. Someone has very aptly likened one type of desert plant, the cactus, to a great pin-cushion whose pins have the points turned outward. This very vividly impresses itself upon one in a land where there are hundreds of different cacti all bearing spines, for even the ground is not exempt, but is covered with small varieties whose sharp points even pierce through shoe leather.

An excellent example of the taller plants with pin-like foliage is the beautiful cholla. It is a strange shrub-cactus with a ragged foliage in great bunches of barbed spines, and presents a most imposing appearance, like a huge bouquet of silver-green thistles, with a sprinkling of pale yellow in fruiting season. Two other plants of the bramble type are the crucifixion thorn, with exceptionally long needle points, and the ocatilla, with long willowy stems, which in the wet season bears fine little leaves, but which in the dry season are replaced by thorns. A slight acquaintance with weather conditions on the desert, makes very clear the reason for this scant foliage, and explains why so many plants are thorny. This, however, is but the part of the protective scheme with which nature arms herself to shield herself from the weather; for the bristling forms also keep away animals which might attempt to get too great a quantity of the stored water, so much desired by them, but equally necessary for the preservation of the plant.

A second means for lessening evaporation is employed by all kinds of plants, it is a coating of the leaf and stem surfaces with an impervious covering. This varies with different plants, as some have hardened and waxed the skin, while others have shellacked it with a resinous substance like varnish, but all in one way or another, have brought the surface to a close texture or glazed it. In these ways vegetation has protected itself: the cacti with many spines; the beautiful paloverde with coated green stems and feathery foliage; the mesquite with long roots, seeking deep underground moisture; the occasional willows and cottonwoods along the dry water courses, together with the few other plants. Forbidding as this region may seem, the charm of its weird and wonderful vegetation, its clear atmosphere, its sunset colors, its mysterious night, and its phantom mirage, makes it far from an unpleasant spot. To the Papago, in their foothill villages among the mesquite and the cactus, and to the Pima, among the cottonwoods and willows along the Gila and the Salt, belong the beauties of the desert as well as its many discomforts and limitations.

The general physiographical and botanical characteristics of this desert home have been lightly sketched as they are so strongly reflected in the textile arts of these people. As plant life has been compelled to adapt itself to the physiographical and atmospheric conditions of the arid environment, so likewise the Indian has had to follow in the same path and fit his arts and industries, his devices and methods of meeting daily needs to the conditions of his physical surroundings. Destitute of material suitable for textile work, as this environment may seem, these Indians have adapted that little to their need. This, of course, is true of all aboriginal industry, but the extreme conditions of the desert simplify things to the lowest terms, so that it is easy to trace influences and to draw conclusions because they are so self evident, as is impossible to do in regions more copiously supplied by nature.

INFLUENCE OF ENVIRONMENT.

It is a recognized fact that the culture and industry of any civilized nation is biased to a large degree by the geographical characteristics of its locality, for there are "ties infinite in number, which bind life to the earth." [1] Even more easily traced is the bias imposed by the climate, topography, flora and fauna of a region upon the arts and life of people of lower culture, since here means of communication and transportation are restricted, although not entirely limited, but enough so to render exchange with distant peoples impracticable. The dependence of the culture of early peoples upon environment is a subject widely discussed by ethnologists, who have shown conclusively the stamp it has placed upon the arts of a particular area. Likewise, the studies of ethno-botanists have pointed out very definitely, though in a narrower field, the relationship between plant life and the technic employed in the various industries. In none of these industries is the interdependence more pronounced than in textile manufacture, for as Mason has said:—

There is no work of human fingers that furnishes a better opportunity for the study of techno-geography, or the relationship existing between an industry and the region where it was developed than the textile art. [2]

The reason for undertaking this much considered topic in its relation to the basketry of these tribes, is because it works out with such nicety in the Papago-Pima geographical area. Environmental influence can be traced in the textile arts of any locality, but it is more adequately shown

[1] Brigham, P. "Problems of geographic influence," *Science*, Feb. 9, 1905.
[2] Mason, O. T. "Woman's share in primitive culture," 41.

in an arid region. The very scantiness manifests this minutely and the governing influence discloses it more plainly, so that dearth of materials makes possible the drawing of closer distinctions and surer deductions than could be made in a richer environment. When one recalls the vegetation of this region, as described in the last chapter, he will surely ask, "Where indeed among these parched, spiny plants and shrubs can be found suitable material for the manufacture of basket receptacles and utensils in which to collect, store, and prepare for cooking the various foodstuffs, and to supply other household demands?" With all the protective means employed by desert plants to keep them provided with moisture, none seems sufficiently successful in this, to yield other than brittle dried-up stems and twigs, so that suitable material is indeed scarce. Nevertheless, the Indian woman finds that even the desert affords a sufficient supply, although it requires much effort and skill to discover just what is of value. Long years of painstaking search were necessary in the preparation and adjustment of these to the function at hand, but in all this she has been successful. The manner in which the Pima and Papago women have made this selection and adjustment, the way they have economized the scant supply of the few best materials, and have adapted to the greatest advantage the less desirable ones, show much ingenuity and invention.

Like all desert regions, this one furnishes many unique examples of the adjustment of plant life to climatic conditions, as pointed out in the foregoing chapter, where it was shown how the geographical surroundings had hindered plant growth, and how plant life in its desperate struggle for existence had effected an adaptation to overcome hindrances of habitat, by bringing to pass certain physical changes, such as modifying the structure to provide for the storage of moisture and to prevent the loss of the same by evaporation. In like manner, this desert vegetation has exerted an influence upon the material activities of the tribes, and the tribes in turn have adapted these activities to the limitation of the desert. Indeed, these austere conditions have rendered it necessary to put forth strenuous effort to perfect the adjustment. It is interesting to trace in Papago and Pima basketry, the restrictions imposed by the thorny, spiny vegetation, which proves but crude material for basket work. These brittle spiny stems and leaves set their imprint upon this art, and determine to a large degree the method of construction, both as to kind and quality of technic, for as marvelously as the vegetal life of the region shows the effect of adverse conditions, just as wonderfully does the basketry exhibit the imprint of the unsuitable materials furnished: Papago basketry that of the plant life of the foothills; Pima basketry that of the vegetation of the river valleys. Thus, because of the material required in the construction, certain technics are allotted to

both tribes, and others are assigned to each tribe, while similar technics common to both show noticeable variation from the same cause, that of available material.

The most striking fact in the relation between environmental conditions and the basketry technology of the region is that this agency has excluded the two most common kinds of weaving, wicker and twined, which are generally found in regions where basketry is practised. The usual plain weaving, or wicker, a technic almost universally employed by aboriginal peoples throughout the world when a heavy style of construction is demanded for rougher domestic purposes, is notably absent. Wattling, or twining, another type of weaving which, with wicker, is an equally frequent technic for strong basket ware the world over, is also not present. An abundance of bendable twigs, or splints is required for the manufacture of these two technics: strong, slightly flexible ones for the foundation element, and slender supple ones for the binding element. On the desert, pliable twigs, or even semi-pliable ones are scarce, and the scant supply from the few willows and cottonwoods along the streams does not warrant their use in the wholesale manner demanded by wicker and twined weaving. The few pliant twigs are too precious for this; each twig must be made to cover as great a surface as possible by being split many times and thus serve as a number of strips. The utilization of these thin strips necessitates another kind of basketry than that of weaving — coiling — where a more economic employment of the limited flexible material is possible. Hence, the exclusion of the heavy openwork technics of wicker and twined weaving and the development and extensive use for heavy coarse structures of the third type of weaving, wrapped weave, a technic whose presence is due to desert conditions (Figs. 1–10). Dearth of sufficient material, save stiff slats and rods for the foundation and strips of hide, thong, and other cord-like material for the binder, make possible wrapped weaving of two varieties, plain wrapped weave, and lattice wrapped weave (p. 140). Here the technic serves most frequently for staying and strengthening bands, quite rudely made, and difficult to recognize as similar to the close textures of lattice wrapped weaving on bags and caps of the Nez Percé Indians, baskets and hats of the Makah Indians, baskets of the people of the Lower Congo, or the colored borders of the beautiful flax robes of the Maori of New Zealand, where finer materials make possible these closely woven and refined textures. Neither can it be compared with the coarser strong openwork wrapped weaving of the Filipinos, or the Málay Islanders, who have at hand the pliant bamboo in place of the stiff desert materials of these tribes.

The materials here are of the crudest kind. The giant cactus, Saguara (*Cereus giganteus*), has a wide distribution in the higher and lower foothills, with a scattering down to the plains, and is therefore accessible to the

inhabitants of the foothill villages and not far distant from those in the alluvial bottomlands. It is split open, and the great stiff ribs furnish light firm rods and slats which will serve as a firm foundation element. The long roots of the widely distributed mesquite tree (*Prosopis veluntina*) supplies another material, but one harder to get, as it must be dug; still, it has a serviceable quality when a curved foundation element is desired, as for cradles, since it can be bent when still green. In the valleys the cactus is supplemented by another equally suitable material when small foundation rods are needed, the stems of the arrowbush (*Plucea borealis* and *Plucea sericea*). A pliable binding element was not so easily discovered, since plant life yields nothing save the too precious willow and cottonwood twigs. So the Indian woman was obliged to search elsewhere, and has found in animal sinew and thong suitable binding materials, while civilization has added two others, strips of cotton cloth and wire.

Another technic found in both tribes and one contrasting sharply with the heavy wrapped weaving is lace coiling, a light airy basketry technic made possible by the presence in the region of the fiber yielding plants: agave (*Agave sp.*, *Agave heteracantha* and *Yucca elata*) among the Papago; and the maguey (*Tasylirioni Wheeleri*) among the Pima (see p. 225). As these plants grow in the higher hills of the two habitats they are easily accessible to both tribes, although to procure them the Pima must journey farther from their home in the valley than the Papago from theirs in the foothills. The tribes constructed their kiahas or carrying frames of the lace coiling. The early Pima kiaha, judging from the one collected by Edward Palmer[1] in 1885 and now in the Smithsonian Institution, differed in shape and intricacy of technic from that used later by both tribes, and now made exclusively by the Papago. Its inverted cone shape was taller and more tapering, the open lacework was of simple design, with the appearance of having been made entirely for service. Its frame was not prominent or distinctive, neither did its four poles extend below the lace cone, and only a short distance above. They crossed just below the lacework, and then followed the lace wall of the slender cone to its rim without much spread, and were cut short a little above it. This Museum also has a small kiaha (65–168) of similar shape collected in 1895 from the Cora. Its frame is of a wood like bamboo and its lace covering of simple design. The Papago kiaha of twenty years ago is notable for its elaborate openwork covering and conspicuous frame (Figs. 75–79), and its form is a more shallow cone, in contrast to the deeper cone of the early Pima shape, while the covering is not of plain lace coiling, but one with complicated pattern, surpassing in elaborateness that of lace coiling from other tribes. The framework also dif-

[1] Mason, O. T. "Primitive Travel and Transportation," *Rept. Nat. Mus.*, 1894, 470.

fers from the early Pima kiaha frame as it holds a prominent place, stretching its four poles far above and below the lace cover, with a rapid spread as they follow the wall of the shallow cone. Two of the lower ends continue some thirty centimeters below where they cross (Fig. 75), thus affording a support when the kiaha stands for loading, or when not in use; likewise, two of the upper ends, the front ones at times reach a length of ninety centimeters (Fig. 80–81). It is these spreading, sprawling poles which give to the Papago kiaha its strange spider-like appearance (Figs. 75–81).

Kiaha use has experienced a change within a score of years. Twenty-five years ago there were two styles of kiahas, a Pima type, and a Papago type, while today there is but one, the old Papago kiaha. The information gathered from the Pima women in 1910–1911 showed that most of the kiahas in use for the past fifteen years, had been purchased from the Papago either in completed form, or in a finished lace cover, ready to be stretched on a frame. Two women reported that they had made the lace cover themselves, but both had procured the fiber cord from the Papago. No woman was found who had gathered the maguey leaves and made her own cord. Still Frank Russell,[1] from information gathered in 1901–1902 describes the Pima women as gathering and preparing their maguey leaves, spinning the fiber cord, and fabricating the kiaha of the Papago. It is probable that there were then living elderly women, now gone, who still held to the old practice of maguey gathering and cord-making, but who in the transition had adopted the more beautiful Papago type, like those which neighbors were procuring through trade. Why the Pima began to purchase the Papago kiaha can have but one logical explanation, that of environmental influence. The transportation facilities brought about through the introduction of the horse and wagon, made it easier to trade for the kiaha with the Papago, whose material was nearer at hand, than to climb to the distant hills for maguey. The giving up of the old Pima type would naturally follow, and during the transition which preceded this, the copying of the more beautiful Papago kiaha would be an easy matter and a normal sequence.

As rigid materials, together with sinew and thong, have given wrapped weave to both tribes, and fiber plants have provided the lace coil, so still other materials have brought a third technic, foundation coil (Figs. 35 and 59) of the coarse and close varieties (p. 190). The two elements which compose foundation coil, the binder and the foundation, perform different functions in technic building, and thus call for materials with unlike qualities. The exacting element is the binder, a narrow splint-like strip which does the work of uniting the adjacent rounds of the foundation, for this

Russell, F., "The Pima Indians." *26th* **Ann.** *Rept. Bur. Ethno.,* 140–143.

active element must wind about the foundation coils in a tiny spiral catching them together. Stiff materials are impracticable for this, as they crack and break. The foundation element needs less care in its selection, harsher materials may compose it, since it is simply a bunch of splints loosely coiled about the basket as a passive foundation, over which the binding element moves, by first encircling it and then passing through the upper edge of the last round of coiling before taking another turn about the foundation. Thus, one can understand that the close winding spiral demands a flexible material and one of some strength. The shrubs along the banks of the one desert stream, the Santa Cruz, furnish the Papago a little pliable material for the light colored binding element, but throughout the greater part of their land, one material only is supplied the basket maker of coiled ware, the seed pod of the martynia, or devil's claw (*Martynia probosidea*) which contributes black binding splints for both tribes (see p. 202). In the Pima country, lying to the north and in a region a little less arid, vegetation changes slightly by the addition of a few desert streams, which although dry most of the year, receive sufficient water in the rainy season to sustain along their banks a few willows and cottonwoods, whose young shoots furnish the Pima with material for the light-colored binding element and some to trade with the Papago (see p. 199). Hence, both tribes are supplied with the materials for foundation coiling of the close variety. Materials for the coarse variety of coiling are supplied by each habitat: to the Papago, beargrass (*Nolina erumpems*), young ocatilla stems (*Fouquieria splendens*), splints of saguara ribs (*Cereus giganteus*) and occasionally wheat straw (*Triticum vulge*) for the foundation element and mesquite (*Prosopis veluntina*) and other barks for the binding element; to the Pima, wheat straw for the foundation, and willow (*Salix nigra*) and mesquite (*Prosopis veluntina*) barks for the binder.

As has been seen the general distribution of certain plants over the entire area has apportioned to both tribes the basketry technics of wrapped weave, foundation coil, and lace coil. A more limited distribution of different plants in the two habitats assigns to each tribe a distinct technic: crude coil to the river villages of the Pima and plaiting to the higher foothill villages of the Papago. In the Pima country the two rivers, the Gila and the Salt, although fluctuating streams and dry most of the year, supply in addition to the cottonwoods and willows, the water shrub arrowbush (*Plucea borealis*, and *Plucea sericea*). This furnishes a type of basketry found in very few parts of the world, as it appears to be solely a desert technic, and to have developed where there is a scant supply of basket material as in southwestern North America. The technic is crude coiling (see p. 172), which constructs the peculiar shaped granaries seen upon many of the houseroofs

or raised platforms (Figs. 29–30). These old nest-shaped structures with overhanging covers are an elementary coiling (Fig. 27), extensively found among the Pima, but wanting, for lack of suitable material, among the Papago. An exception to this was found in two hive-shaped granaries of this technic seen in one Papago village near the Santa Cruz (Fig. 28), where material of this character was obtainable. It seems quite probable that dearth of refined material suitable for the more perfect technics, especially the scarcity of pliable binding elements, must have been largely responsible for the development of crude coiling.

The Papago have sought the heights of their land in preference to the dry valleys since they are dependent upon wells for water which is reached at less depth there than in the valleys. This location gives them access to the thick-stemmed, thick-leaved plants of the higher altitudes: the giant cactus, agave, yucca, and palmea. Of these, one of the most important for basketry is the palmea (*Dasylirion Wheeleri*), growing on the dry rocky slopes of the higher foothills, four thousand feet above sea level. It is the only plant in the entire region now employed for plaiting sleeping mats, headrings, kiaha mats and headbands (Figs. 11, 19, 20, 75, 80), medicine and trinket baskets (Figs. 26 and 21, see p. 150). It is a plant quite similar in growth to the Spanish bayonet, and bears a long slender leaf of light green, edged with thorns. When cleared of these ánd split in half, it forms a suitable material for plaiting the mat-like surface of this technic.

All plaiting requires for manufacture bands of flexible material, but its three types demand different degrees of pliability. Checker plaiting needs the most supple, and no material in the region fulfils the requirement; lattice plaiting admits of less pliant strips, but they must be very strong, and no material is present which is sufficiently substantial and yet will bend without breaking. Material for the third type, twilled plaiting, is supplied by the palmea on the higher foothills, and since the Papago are great travelers, the short journey for this material is not troublesome. The arrival of civilization, with greater trade facilities, has linked even more closely the habitat and the practice of this technic by limiting plaiting to the few villages nearest the mountains, where each year more and more plaiting is done and less in the lower villages, so that from the Indian women of the higher villages plaited articles can be obtained by the Papago as well as the Pima. Occasionally, to be sure, there is found an old woman in some of the other Papago villages, who prefers to continue the old art and do her own plaiting even if she is put to considerable inconvenience in procuring material. A great many years ago, plaiting was done by the Pima, but owing to the shutting off of the headwaters of their two rivers by the white men, these streams are dry during most of the year, and the one suitable plaiting material, the river plant, *Phragmetis communis*, which formerly

grew along their banks is no longer found. This river cane was a stiffer and less durable material and much more difficult to manipulate than palmea, so that its use was limited to mattings as it was unsuitable for baskets, or articles not flat. Hence, because of this change which cut off the material, the Pima do not plait as of old, and altered conditions have restricted the technic to the Papago.

The presence throughout the entire area of the three technics: wrapped weaving, foundation coiling, and lace coiling, owing to the general distribution of certain plants has been discussed; as has also the allotment of a distinct technic to each tribe: to the Papago plaiting and to the Pima crude coiling, because of a particular plant material found in each habitat. There is still to be considered the influence of the vegetation in each habitat upon a technic common to both tribes, that is foundation coiling, with its two varieties, close and coarse coil (pp. 179 and 190). As has been said, the manufacture of close coil is very greatly hindered by the scarcity of material for the flexible binding element, calling forth interesting economic adaptation of the scant supply. But it is the foundation material that is of interest here, for although it does not need qualities of flexibility, strength, and adaptability to the degree called for by the active binder, its characteristics have a marked influence upon the finished product in qualities of build, texture, and accuracy in technic. The material commonly employed by many tribes for the foundation element of close coiled ware is willow splints, but as a great quantity is consumed by the foundation, this region does not afford a sufficient supply to meet the demand and the scant amount is too precious for an extensive use of it. Therefore, the Papago ordinarily employ beargrass (*Nolina erumpems*) from the foothills, or occasionally Spanish bayonet (*Yucca baccata*); and the Pima use cat-tail (*Thypha angustifolio* Linn.) from along the streams, or less frequently brittle cottonwood splints (*Populus fremontii*) (see p. 198). The use of unlike materials would obviously affect the finished technic and this is demonstrated by the contrasting qualities which these materials have left upon the close coiling of these tribes, for the harsh beargrass gives to the Papago basket a heavier, stiffer, and firmer construction and to the Pima a lighter, thinner, and more pliable one which is also less durable (see p. 251). From the abundance of martynia and the lack of light-colored binding splints in Papagueria springs another modifying agency, which results in a dominance of black in Papago ware; but even where both dark and light material are present, the greater difficulty in preparing the martynia splints, results in a dominance of light in the Pima ware (see pp. 202 and 250).

As noticeably as is close coiled ware in the two tribes differentiated, because of distinguishing qualities given by the materials, so also are the coarse coiled granaries, since here also unlike materials have left their

imprint upon both the shape and the quality of technic (p. 183). The Pima foundation material is wheat straw, a smooth, even, shapable material; the Papago is beargrass, young ocatilla shoots, or strips of the inner rib of giant cactus which can be split like bamboo, and very occasionally wheat straw, all materials much less pliable and harsher to handle. The Pima binding materials are the bark of willow, mesquite, and other trees; that of the Papago mesquite bark and yucca. The controlling agents here, as in close coil, are the foundation materials, whose qualities are responsible for the dissimilarities. Their influence on form gives to the great globular and bell-shaped granaries of the Pima, using the more pliable wheat straw, a shapely contour and beauty of line; and to the barrel shapes of the Papago, using beargrass and other harsh materials, a less symmetrical basket receptacle, with imperfect outline (Figs. 34–35). Influence of material even extends to the quality of technic, since the wheat straw multiple foundation can be more skilfully managed, allowing an evenness to the technic and a precise arrangement of the spiral segments of the binding element which runs in lines from the base to the rim (Figs. 32 and 34). Not so with the Papago granary, the harsh unwieldy materials do not conduce to anything but a rough "hit or miss" setting of the spiral segments of the binding element (Figs. 33 and 35).

WRAPPED WEAVING.

The earliest basketry of this locality, in all probability, is a weaving technic constructed of a series of parallel rods forming the warp, and a uniting weft. The commonest types of weaving, wicker and twined, are, with one minor exception, not present, since there are no suitable materials

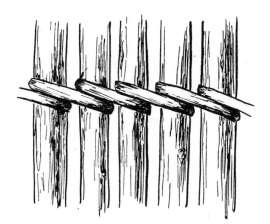

Fig. 1 (50.1–5279). Wrapped Weaving Technic.

for their manufacture. Basketry wicker work, or plain weaving, which finds an almost universal use in coarse openwork structures, and which has perpetuated itself in the loom weaving of the modern power loom, is

distinguished from other types of weaving by its interlacing weft. Twined weaving, another substantial technic which is almost, if not quite, as widespread in use, and which thus far no machine has succeeded in imitating, is distinguished by its twining weft of two or more strands. The third type of weaving is wrapped weave, a technic found here in two varieties, simple wrapped weave and lattice wrapped weave. The weft of this type does not

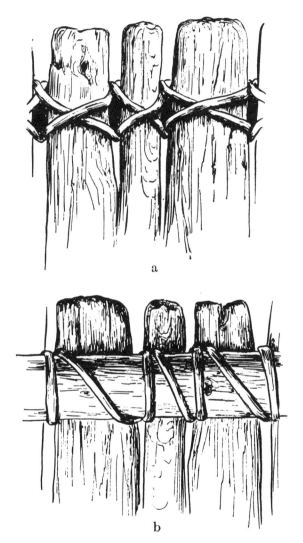

a

b

Fig. 2 (50.1–4861ab). Lattice Wrapped Weaving Technic: *a*, front; *b*, back.

interlace through the warp strands, as in wicker weaving, neither does it twine about them as in twined weaving, but it wraps about each rod of the parallel warp series (Fig. 1). Lattice wrapped weaving is more complicated and stronger than wrapped weaving, as it employs two series of parallel warps crossing each other at right angles. These are bound together at their point of crossing by a wrapping of the weft strand about them (Fig. 2).

In early days, this interesting old weave, crude as it is, supplied many needs of the Papago and Pima. It furnished large, strong openwork structures such as coops and cages in which to keep live wild fowl caught for food; hanging shelves upon which to suspend animal and vegetable food to protect it from rodents, and the ravenous coyote; doors for the huts and storage sheds; and cradles for the infant. All these are fast disappearing with the influx of civilization, indeed, only four basket doors of simple wrapped weaving were seen in the two dozen villages visited. These pliable doors fold back upon themselves, as the soft weft binder of skin thong which

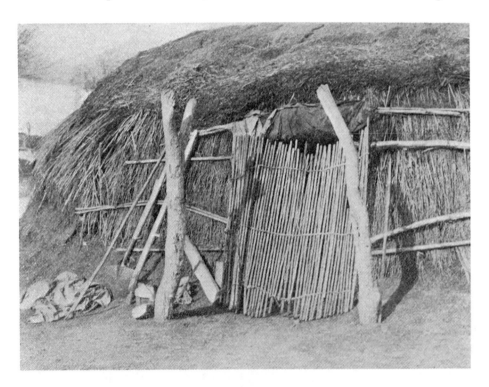

Fig. 3. Oldest Type of House showing a Door constructed with Rows of Wrapped Weaving.

unites the parallel slats of giant cactus rib constructs a mat-like form which will roll from the two sides (Figs. 3–4). Old oval shaped sieves with a strainer of wrapped weaving, are even more scarce (Fig. 5).

The hanging shelf still finds frequent use, where it is seen suspended from the beam of many of the arbors and storage sheds. It is habitually piled high with all sorts of provisions, baskets, pots, and other things. Civilization seems to have made no change in this shelf of lattice wrapped weave, except that in many instances the material for binding together the warp sticks of cactus rib, or other wood, is of store-bought string, strips of

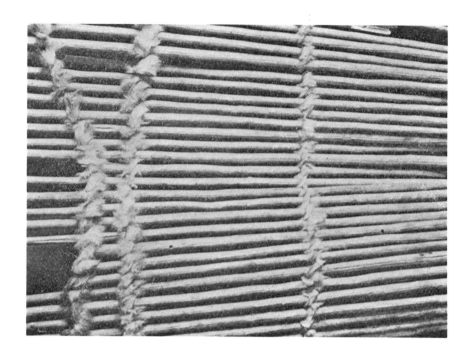

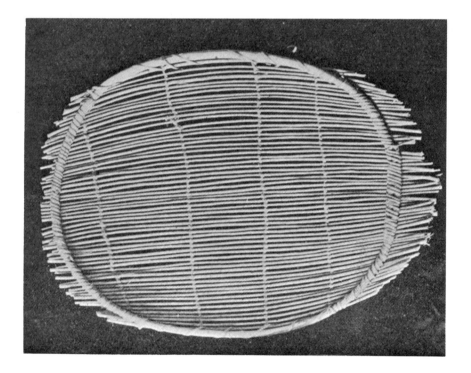

Fig. 4. Detail of Door of Wrapped Weaving shown in Fig. 3.
Fig. 5 (U. S. National Museum). Sieve constructed of Wrapped Weaving.

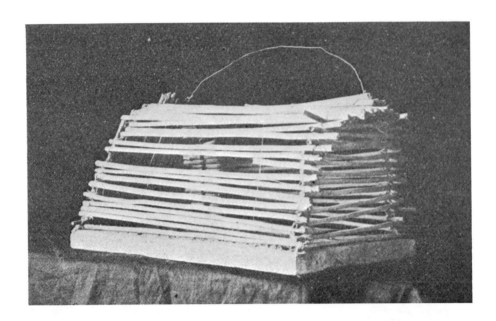

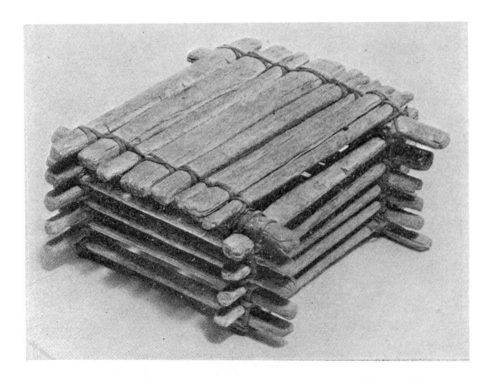

Fig. 6 (U. S. National Museum). Cage constructed of Lattice Wrapped Weaving.
Fig. 7 (50.1-4861). Rectangular Coop of Saguara Ribs and Thong constructed of
Lattice Wrapped Weaving.

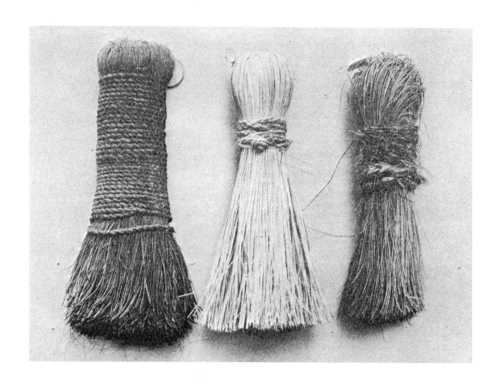

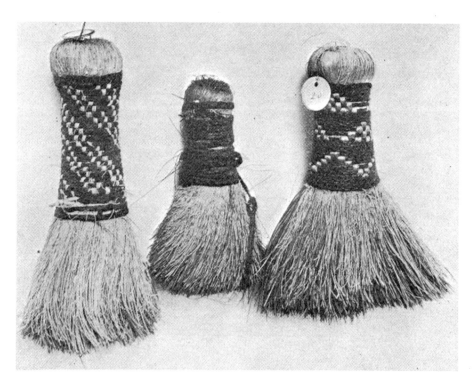

Fig. 8 (50.1–5235, 4537, 4538, 4628, 4554, 5131). Pima Hair Brushes. Varieties of wrapping shown ranging from the crudest binding to ornamental weaving in designs.

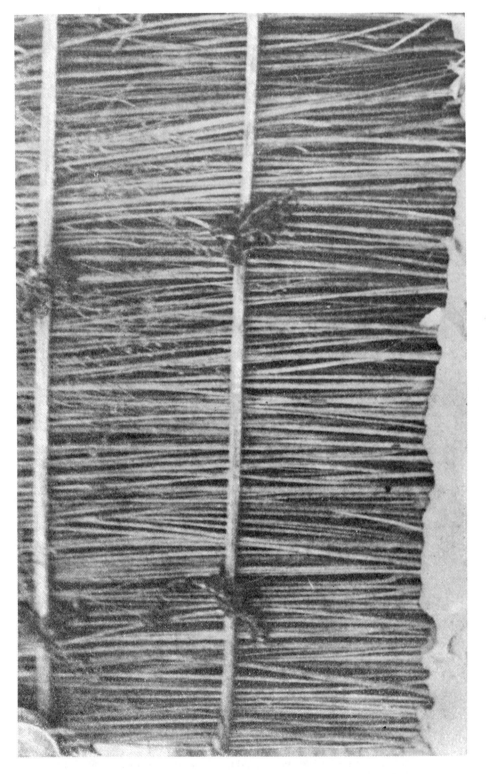

Fig. 9. House Wall. A latticed construction with knottings of willow twigs which may have been the beginning of the lattice wrapped weaving.

cotton cloth, or wire. The coop, or cage, of lattice wrapping is usually rectangular in shape, although at times it is supplied with a rounding top. Sizes as well as materials also vary, although saguara ribs and skin thong are the more usual (Figs. 6–7).

The most common material for the warp element of this weave is the giant cactus (*Cereus giganteus*), the ribs of whose great fluted columns furnish a straight, light, porous wood, which serves admirably as foundation rods on house doors, cages, and the larger shelves. Another material is arrowbush (*Plucea borealis* and *Plucea sericea*), whose larger stems are both straight and uniform in diameter, and which, although of smaller size than the cactus ribs, are suitable for articles where smaller warp rods are needed. The most usual binding elements are thong, the hide cut in strips and slightly twisted; and sinew from the back and legs of deer, split into fine shreds. Cradles are constructed of the mesquite root (*Prosopis veluntina*), saguara ribs, cat's claw (*Acacia Greggii*) and willow (*Salix nigra*); with a binding element of sinew, thong, or fine mesquite roots, used while still green. Papago hair brushes are generally of agave fiber (*Agave sp.*); those of the Pima are of grasses, the tripled awn (*Aristida californica*), and Sacaton grass (*Sporobolus wrightii*); of grass roots; of yucca fiber (*Yucca baccata*), or agave fiber (*Agave lecheguea*).

The crudest form of wrapped weaving occurs on the hair brushes of the locality. The technic is merely a winding and fastening, as the fiber, grasses, or roots are simply bunched together and wrapped toward one end, at times with crude craftsmanship, at others more perfectly (Fig. 8). A more advanced wrapping, sufficiently so to be termed wrapped weaving, is that found on the house doors, sieves, and stirrers (Figs. 3–5). Here the rods and stems of cactus ribs, arrowbush, or other stiff materials, are laid in a parallel series to form warp, and the pliable weft of sinew, or skin thong, is wrapped in a single strand about them. This moves across the parallel series forward over two rods in front, between the rods, backward over one rod behind, and between the rods to the front, to again repeat the process, and so continue until the series of warp rods are all united (Fig. 1). More of such lines placed only close enough to stay the rods complete the surface seen in Figs. 3–5, producing a rough, pliable technic of wrapped weaving, which is widely distributed among peoples of lower culture.

An elementary basket technic enters into the house construction of these tribes, a crude form of lattice wrapped weaving, for a vertical series of parallel slats are crossed by a horizontal series, and knotted together at intervals by a bit of green twig, or of bayonet leaf. Fig. 9 shows a part of the wall of such a brush hut, with its basket-like technic of wrapping. A framework of the trunks and saplings of cottonwood, or willow, is first

erected, whose walls are built of standing stems of ocatilla, or arrow-bush, and securely held in place on both the outer and inner surfaces by horizontal slats which cross the vertical stems at short distances apart. The process of uniting the outer and inner horizontal slats to the upright stems is a wrapping and then a tying of the binding twig, or leaf, and differs from basketry lattice wrapped weaving only in this tying. The widely separated joinings in hut construction, because of the distance between, necessitates a breaking of the wrapping movement, which in the closer joints of basketwork is carried in a continuous and unbroken movement from one joint to the next (Fig. 2). The short lengths of the binding twig, or leaf, will answer the purpose in house construction, but a longer element, one of sufficient length to wrap several joints and usually supplied by skin thong, or sinew, is required for lattice wrapped weaving.

The crudest form of lattice wrapped weaving of the Papago and Pima is found on their cradles, a formerly used article, but one which owing to conditions of change has almost disappeared. The almost universal basket cradle of California and the adjoining desert region varies greatly in the different localities as to construction, shape, and decoration, but its technic always holds to some form of weaving, either wicker, twined, or wrapped, each in the region where vegetation is best suited to that construction. The most perfect cradle, both as to shape and technic, is made by the Hupa Indians of northwestern California, a slipper-like shape of twined twigs. Between this perfect form and the simplest is a long series of great variety, the crudest being that of the Tonkawa, Oklahoma, Walapai, Mohave, Papago, and Pima, which consists of a simple frame of rods and slats, bound together with a rough wrapping and double tying, quite similar to Papago and Pima hut construction. It is a technic which hardly can be dignified as basketry, but shows rather an interesting transition between the simple tying process and lattice wrapped weaving (Fig. 10).

The primary use of the cradle was not for transportation, but for putting the infant to sleep when it grew drowsy. Indeed, the child often cried for its cradle and was quiet when strapped in, but was always removed as soon as sound asleep. When employed as a carrier, the cradle frame was either placed on top of the loaded kiaha, or rested horizontally on the mother's head, with its arched hoop to the front for a handle. Older children were never carried in the cradle, but, as now, astride the hip supported by a strip of cloth or a shawl.

The arched hoop, or the foundation of the frame is of willow, cat's claw, or mesquite root, and more frequently of the last. The mesquite tree needs more moisture than other desert vegetation, so that in Papagueria it grows along the dry water courses, sending out its roots to great depth in search

of underground rivulets. In the Pima country it grows along the streams where its long projecting roots hang from the banks, reaching for river water. In the first region one must dig deep for these roots, and in the second trace far back into the bank to reach roots of sufficient size for the cradle frame. Upon bringing it home, the root is immediately skinned by means of the teeth and fingers, and should the skin be slow to yield it is loosened by being held over the fire. It is then cut twice the length of the proposed cradle, heated and arched by placing the foot upon its middle point and bending up the two ends and tied in position until dry, when the bent root retains its arched shape. At times the root is so soft that if taken while still green, it can be shaped without heating. The arched hoop having been prepared, cross bars of giant cactus rib are cut the length of the distance between the

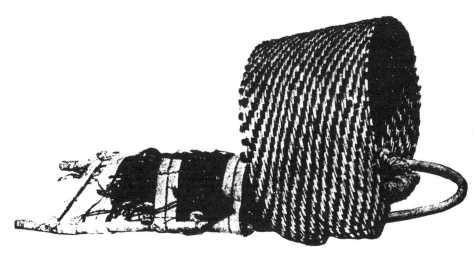

Fig. 10 (50.1–5248ab). Pima Cradle. The frame in this specimen is of crude lattice wrapped weaving, the hood of twilled weaving, the mattress of bark, strapped on by an old suspender of white man's manufacture.

arms of the cradle arch and bound to them with sinew, or thong, in a crude lattice wrapped weaving (Figs. 2 and 10), or attached by a coarse lashing.

The hood, or shade of the cradle, is constructed of splints of willow, or other pliable twigs, which act as the warp; and willow bark which supplies the weft. This interweaves into the split twigs in a twilled weaving of over two, under two, and in a design quite similar to that on mattings (Fig. 10), in zigzag lines, or in graduated squares, as on plaited mats and baskets (Fig. 15b). The Mohave Indians attach feathers and bits of bright flannel to the cradle hood, contrary to the Papago and Pima who leave them undecorated other than the design of the wickerwork. The mattress, to protect the infant from the cross rounds, is of willow bark or wads of cloth. The present-day straps for holding the infant securely to its cradle, are of plaited cloth strips, plain cloth strips, or old suspenders (Fig. 10).

PLAITING.

One of the simplest, as well as one of the most important basketry technics of these tribes is plaiting, which is represented by a single variety, that of twilled plaiting with oblique elements only. The technic here is of equal rank with coiling, as one of the two most utilized, since articles of this construction enter largely into the economy of both the Papago and Pima households. It provides mats upon which to sleep, to eat, and to dry grains, beans, peppers, and other vegetables; headrings, for carrying the olla and the large basket bowl; the headband and back mat for the kiaha; cylindrical baskets for holding trinkets, clothing, and foodstuffs; and rectangular baskets for medicine and magic to drive away the evil spirits.

Mattings from peoples of lower culture in different parts of the world vary in technic, but the most common construction is that of plaiting, either with vertical and horizontal elements, or with oblique elements. Pima and Papago matting, as before mentioned, is of twilled plaiting of the oblique variety, constructed of two series of parallel strips crossing each other at right angles. The strips of both series are of equal width and pliability, and contrary to the weaving technic, both series of elements are active, moving over and under each other with equal ease. Neither is there a definite direction to the technic, as in weaving and coiling, since the elements can plait in any, or in all of the four directions, which the worker may desire. The movement on most of these mattings is in one rhythm or count throughout, each element passing with one move over three and under three elements of the opposite series, with an advance of one element as each new leaf strip is added. The rhythm on the old Pima matting seen in Fig. 12, is an over two under two movement, while other less common arrangements may be noted under matting designs.

Palmea (*Dasylirion Wheeleri*) is the plant from the rocky foothills which supplies the Papago material for plaiting. Its growth is similar to the Spanish bayonet, with long light green thorny-edged leaves arranged about a thick central stem. The leaf of the palmea is the useful part of the plant for plaiting, and is in perfect condition to be gathered at any time of the year. Its harsh spiny edge makes it difficult to collect, necessitating the use of a stick for breaking off the leaf; so that for the gathering, the women travel afoot armed with long sticks for severing the leaves. When a sufficient number has been secured, they are carried home in bundles on the head, or in the kiaha carrying frame on the back. On reaching their destination, the leaves are first cleared of their thorns with a knife, and then split lengthwise through the center, and spread on the ground to dry.

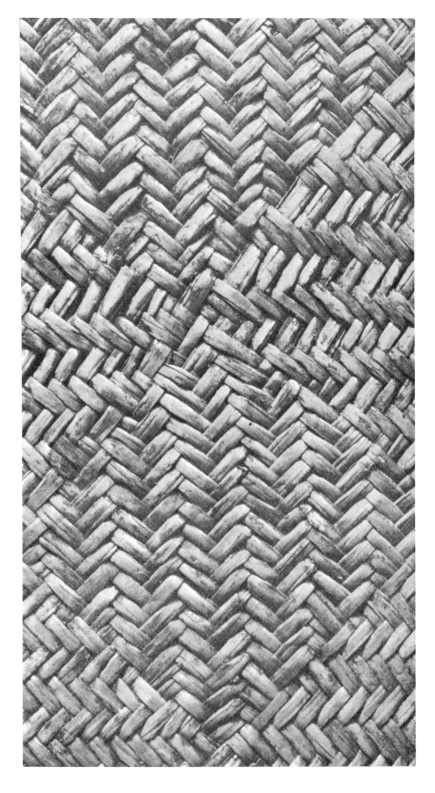

Fig. 11 (50.1–5232). Papago Eating Mat. Two-ply twilled plaiting with a design found only on eating mats and never on sleeping mats.

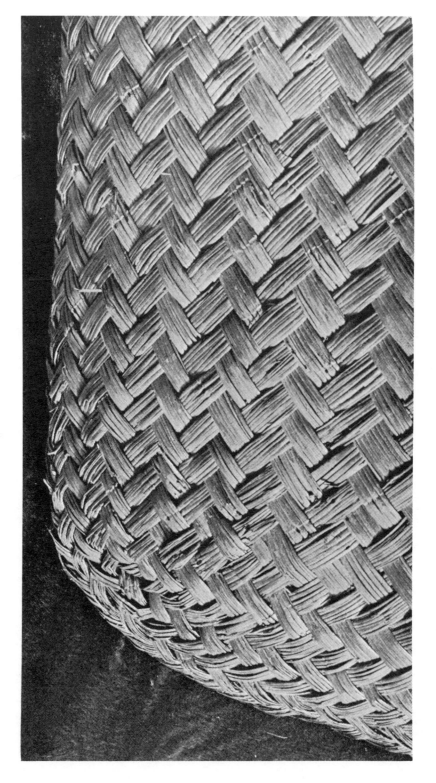

Fig. 12 (50.1–5315). Pima Mat. A rare old specimen since the river grass of which it is plaited no longer grows along the streams.

When needed for plaiting, the dried leaf strips are first buried in a hole in the ground, water poured over them, and then left in the damp earth through the night. By morning, the strips have become slightly dampened through-out and are pliable enough to plait without cracking.

The cane, *Phragmetis communis,* was the river plant which served the

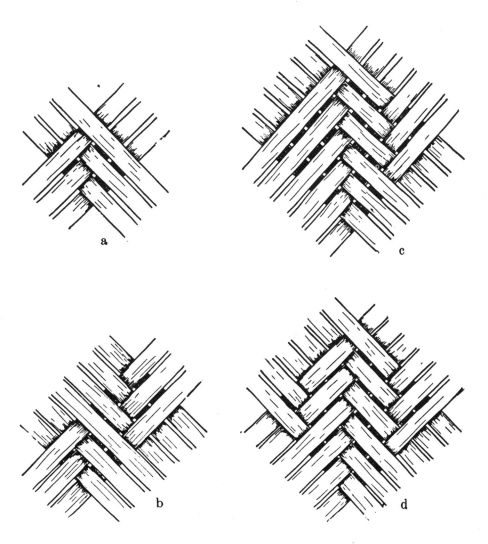

Fig. 13. Method of Mat Plaiting.

Pima for plaiting in times past before the headwaters of their streams were diverted, and the rivers deprived of water. In consequence, *Phragmetis* no longer grows along the rivers, but in former times its hollow stem was found most valuable for the construction of mattings. These plants were cut down with large knives from land near the streams, carried home, and

the stems dried and stored away for future use, but before plaiting the hollow stems were split lengthwise with the thumb nail, and then spread flat.

When the worker is ready to begin plaiting a mat, a few of the dampened leaf strips which have been moistened over night are brought from the pit, but only a few at one time since they dry rapidly in the open air. She then spreads a mat or a square of canvas on the ground upon which to work,

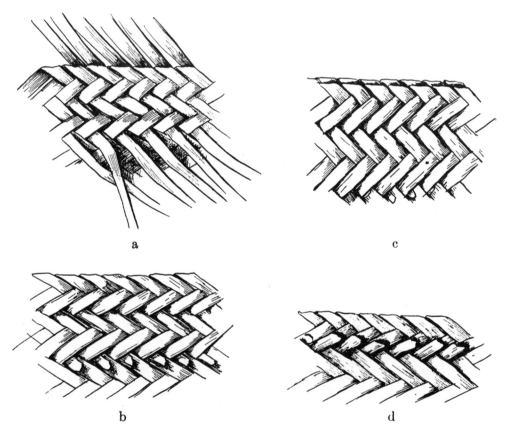

a c

b d

Fig. 14. Edge Making: *a*, beginning of a double edge; *b*, inside of completed double edge; *c*, outside of completed double edge; *d*, single edge.

and seats herself well to the edge with most of the mat in front of her. Upon this she lays her first six leaf strips in two parallel series of three strips each so that they cross each other at right angles. Each strip of the lower series is then brought up one after the other through the upper series in such a manner as to form three successive steps, as seen in Fig. 13a. The two groups of elements must be held in an oblique position to the worker throughout the plaiting, one series trending diagonally to the upper right, and the other diagonally toward the upper left. She adds new strips only to the

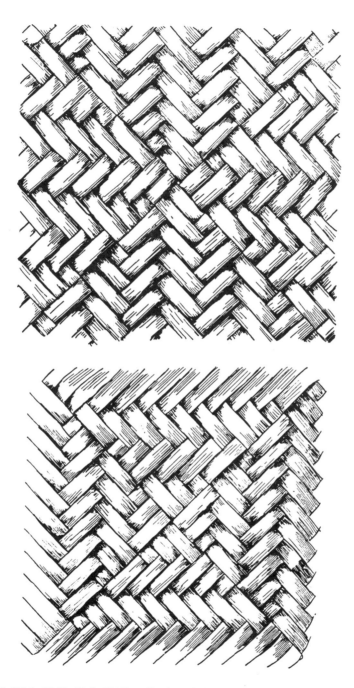

Fig. 15 (50.1–5229, 50.1–5208). Design Units Common in Plaiting, Papago.

farther or upper sides of the mat that they may be more easily crowded toward her for a closely fitting surface, and when more are needed on the near side, she turns the mat around bringing the far sides nearest her, but in every case the elements remain in an oblique position. Three new strips are always added at one time, as in the illustration here, where the first three are laid to the upper right and then plaited in the manner already described (Fig. 13a), by being brought up through the series already in use, to continue the step series already begun (Fig. 13b). Another group of three strips is added to the upper left and so placed as to hold to the plan (Fig. 13c), when they are plaited according to the regular rhythm (Fig. 13d). So the process continues as each set of three strands is added, when the three are plaited in. When splicing is necessary to lengthen a strand, a new strip is lapped for a few inches over the old strand; and when the inconvenience of reaching the spot where the plaiting is in process is experienced, as the mat grows larger, the worker moves on to the finished portion, and continues plaiting from there.

When the mat has reached the proposed size, it may be finished with either of two edges. The double edge is most common on mattings, and is made by bending one series of parallel elements to the front and downward and interplaiting them into the body plaiting on the front of the mat, and turning the second series to the back and downward and interplaiting them into the body plaiting on the back of the mat. More definitely, each element of the series trending toward the upper right is bent at the edge of the plaiting to the front, and turned obliquely to the lower right, at an angle of ninety degrees, and then interplaited for a short distance into the body plaiting (Fig. 14a), and trimmed off (Fig. 14b). The mat is then turned over, when the second series which trended toward the upper left, now extends toward the upper right. These are bent and interplaited as were the elements of the first series (Fig. 14a), making the finished double edge (Fig. 14c). If during interplaiting, the elements do not slip easily into the plaiting, a sharp stick is used to lift the strands, that those forming the edge may pass under more easily. The single edge is less frequent on mattings than the double. It is made by treating the first series of elements as in double edge making (Fig. 14a, b), and then clipping the second series of elements short at the edge of the mat (Fig. 14d).

Design on twill plaiting is more largely influenced by technic than is the design on any other style of basketry. In its simplest varieties, such as are found here, the design appears to be a result of a play with the material, and this play resolves itself into several rhythmic arrangements. As before mentioned, the regular movement of the technic over three and under three, or over two and under two, is a result of the most economic use of

palmea leaf strips and cane stems; but this movement is also of esthetic value as it cuts the surface of the matting into small equal sized rectangular units of design. Different arrangements of these design units give three distinct styles of pattern: an arrangement of parallel bands running in one direction Fig. 12; another of parallel bands perpendicular to each other, part horizontal and part vertical (Fig. 15a); and still a third of parallel bands arranged in squares, a large square composed of smaller graduated squares (Fig. 15b). The grouping of these larger squares is always a vertical or a horizontal one, forming a pattern of squares one above the other, or beside the other.

In addition to the influence of technic on matting design, there is still another, the influence of material. Matting materials in this locality are not strong enough to be serviceable in narrow strips, and wide strips of necessity produce a plaiting which does not admit of many changes in rhythm without weakening the matting. More elaborate twillings, such as those found in the land of the bamboo, are constructed of material which is tough enough to be used in very narrow strands, capable of spanning long stretches of a number of opposing elements, as well as a few, and so allow for great variety in design on a plaiting which also is strong.

Fewer mats are now found on the dirt floors of the one-room Pima hut than formerly, as old customs are fast dying out. The Papago homes, however, are still plentifully furnished with plaited mats of the light green palmea, which turns to a yellowish green with age. At times, the floor is completely covered with them, especially if the family is large, but two or three are quite sufficient for the floor space of the average hut. More frequently one mat only is used, and that is placed either in a corner, or at one end of the hut. These serve mostly as sleeping mats, upon which the blankets are laid at night to lift the sleeper from the dirt floor. In the neater homes, the blankets are folded through the day, thus leaving the mats free as a place to sit. In other huts, the mats are not left on the floor during the day, but rolled up and stood on end in the corner, ready to be unrolled and spread with the blankets when night approaches. The primary use of these mats is for sleeping, but smaller ones are utilized for eating mats (Fig. 11), as is easily recognized by the food spots which stain them. Eating mats serve another purpose during the season for drying foodstuffs, when peppers, beans, corn, or wheat are spread upon them to dry in the sunshine, although the modern square of sacking is at times substituted for this.

In shape, the mats of both tribes are rectangular, either oblong, or square, with rounding corners. The more general oblong form is varied in its proportions to fit the need, but the width is seldom less than half the length. Within some Papago households more than in others, an atmos-

phere of abundance pervades, when the mats take on larger dimensions, even reaching 2.4 m. by 1.3 m. and 2 m. by 1.7 m.; although 1.8 m. by 1.3 m. for the sleeping mat, and 1 m. by 1 m. for the eating mat are more usual sizes.

An additional matting to those which serve for sleeping and eating is the small back mat made for the kiaha carrying frame. This protects the head and shoulders from the heavy load during transportation (Fig. 80a), as it is attached to the front of the kiaha and comes between the woman's back and her load. Its upper corners are tied to the wooden rim of the kiaha, its lower end is secured by the two long poles of the framework, which pass through an opening near the edge. Just above this opening is the spot where the lower ends of the four poles of the kiaha framework cross, making an ugly bunch, which would prove very uncomfortable to the carrier, were it not for the back mat, and the roll of shredded bark, or cloth, slipped in at this point to serve as a padding between the mat and the frame. This padding lifts from the back the hard poles of the frame at their point of crossing, where the load rests most heavily upon the shoulders.

These mats are oblong in shape with oval corners, and have a break, or opening, near the lower edge for the insertion of the two front frame poles which extend some distance below the point of the kiaha. The size of the mat varies in woman's and girl's kiahas to fit the larger and smaller shapes, that of the woman averaging from 60 cm. to 70 cm. in length and from 24 cm. to 28 cm. in width, since it must fit in length, the distance between the rim of the kiaha and its point; and in width, the space between the two poles half way down from the rim, or the point where the headband is attached. The material for the back mat, like that for matting, is the dried leaf strips of the palmea, whose gathering and preparation was previously described. The technic is plaiting of the twilled type, with diagonal elements, and as in larger mattings it is of three varieties of twilled plaiting in over three and under three rhythm, arranged in bands of vertical parallels; in combined bands of vertical and horizontal parallels; and in squares composed of smaller squares. The edge like that on large mattings is of the double type, whose method of making has already been given.

Plaiting supplies the kiaha with another essential part, the headband, or the support for the carrying basket. This is a narrow double band which passes over the head to hold the load securely on the back and shoulders of the carrier. In reality, it is a long narrow mat with its ends joined to form a ring, and then flattened into a double band about 7 cm. wide and 35 cm. long. It is very short, but a rope extension lengthens it, and attaches it to the kiaha at its two ends by passing in a double line under the front poles of the kiaha frame, then down and around the four crossed poles below the kiaha point. The process of making the headband will be described later.

Aside from flat mattings the Papago plait cylindrical and rectangular forms, one of which is the circular headring, Nothing is more helpful to the Indian woman for carrying loads on the head than this small ring about 4 cm. or 5 cm. in diameter, since she must bring from the village well all the water for washing, cooking, and drinking; from the neighboring fields, grains, beans, peppers, squashes, and other vegetables; and from the distant foothills the favorite cactus fruit. She carries these at times in the kiaha on her back, but quite frequently on the head, the water in an earthen olla, or the more modern rectangular three gallon varnish can, and the foodstuffs in a basket bowl. When carrying these loads, she places the little headring on the crown of the head, and the load on top of it, for it acts as a soft pad between the load and the head, and also steadies the basket, or olla, if it have a curved base. A woman so laden is a pretty sight as she steps along with easy gait and erect carriage, balancing, without the aid of her hands, the great weight upon her well-poised head, for it is this practice of transporting burdens upon the head which has given her that grace of bearing which well befits a queen.

The basket headring, like matting, is a twilled plaiting of palmea (*Dasylerion Wheeleri*) leaf strips, but the rhythm of the plaiting never varies from a regular over two and under two movement. Its beginning is a small mat made on the ground with two series of equal width leaf strips placed diagonally in front of the worker. In starting the headring the two series of three strips each, are laid so as to cross each other at right angles near their central point, when the three strips of the lower series are brought up through the upper series as in beginning the sleeping mat (Fig. 16a). The next move in ring plaiting, however, does not proceed as in mat making, for at this stage the edge finish is begun. For this, the upper end of the lower left-hand strip is bent toward the upper right at an angle of ninety degrees and lies just above the upper left-hand strip (Fig. 16b). Three new elements are then added on the upper right, and so placed as to hold to the regular step series of the beginning (Fig. 16c). These are then plaited in regular rhythm, over two and under two (Fig. 16d), when the three are bent to the upper right at an angle of ninety degrees and plaited into the opposing strips (Fig. 16e). This process continues until the finished edge of the mat is the length of the proposed circumference of the completed ring.

When the little mat has reached this stage (Fig. 17), the woman lifts it into her lap and bends it into ring shape, so that the loose ends at the right and left of the finished edge come together. These ends are then plaited to form a cylindrical shape (Fig. 18). The plaiting then continues upward until the cylinder is about three times the proposed height of the finished ring, when each strip of the series of elements trending toward the upper right

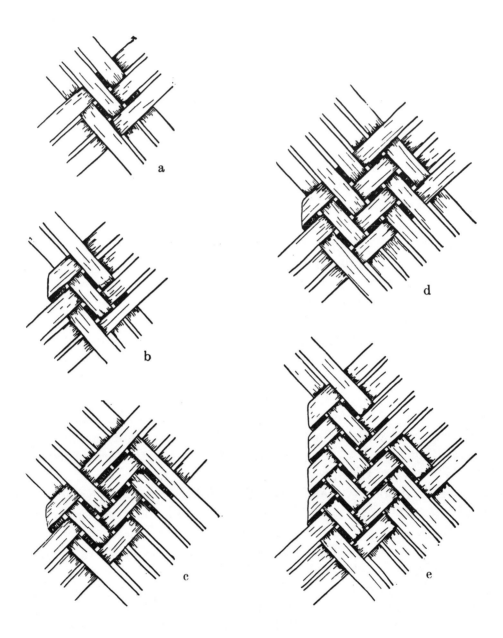

Fig. 16. Method of Plaiting the Headring.

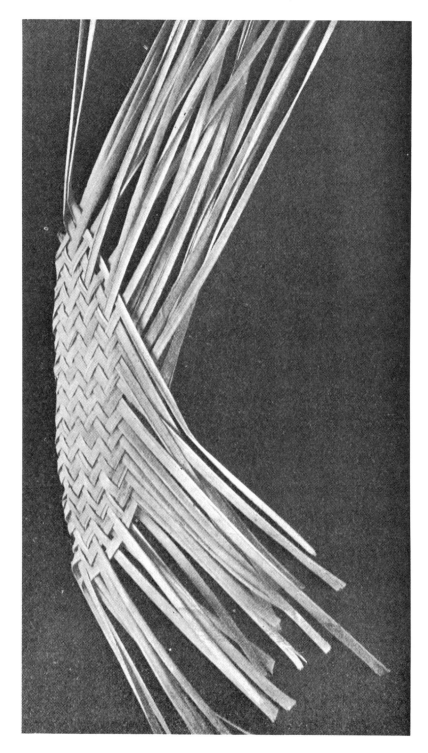

Fig. 17 (50.1–5147). Plaited Beginning of Headring ready to shape into Cylindrical Form.

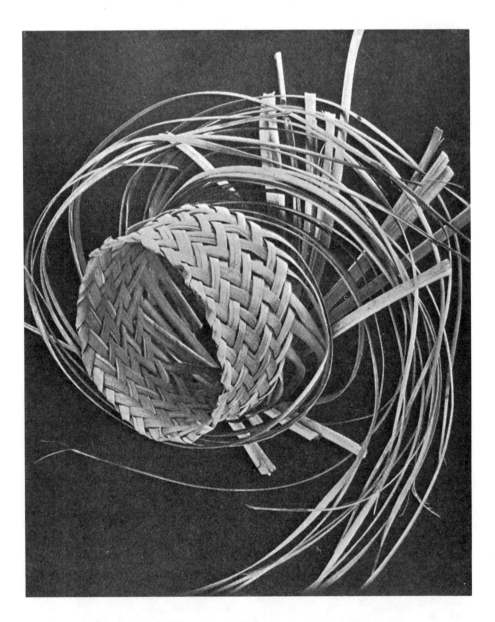

Fig. 18 (50.1–5224). Further Plaiting on Cylindrical Form.

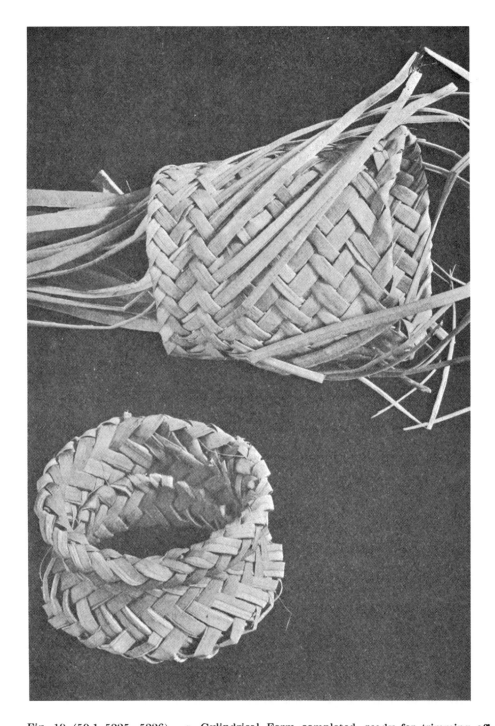

Fig. 19 (50.1–5225, 5226). *a*, Cylindrical Form completed, ready for trimming off Ends; *b*, Completed Headring made by folding the Cylindrical Form.

is bent at right angles and plaited into the body plaiting (Fig. 19a, Fig. 14a) and then trimmed off (Fig. 14b); while the second series of elements, those trending toward the upper left, are cut short at the upper edge (Fig. 14d). The work is still damp enough to fold without cracking into the finished ring, which is done by creasing the tall cylindrical shape into three overlapping folds. A thin leaf strip is then either tied about the middle of the ring or bound about its edges to hold it in shape when heavy loads are carried (Fig. 19b).

The material for making the kiaha headband, already mentioned, is palmea (*Dasylerion Wheeleri*), the usual plaiting material of the Papago; the technic employed is twilled plaiting in rhythm of over two and under two. It is begun as the headring (Fig. 16), but with nine or ten strips only, since this number is sufficient for the narrow width of the band, as they are bent back and forth, in plaiting from edge to edge (Fig. 20). More defi-

Fig. 20 (50.1–5230). Detail of Kiaha Headband.

nitely, after completing the interlacing, as in making the headring, the plaiting continues toward the right until the desired width is attained. Each strip trending toward the upper right is then bent toward the upper left at an angle of ninety degrees, thus forming an edge on the right, similar to the edge on the left, for like a braid, the two edges are finished with the plaiting of the strips diagonally back and forth across the band as the work progresses. When it has reached twice the proposed length of the finished band, its ends are brought together in ring shape and joined by interplaiting as in the headring (Fig. 18). This ring folded flat is the completed headband, which is attached to the kiaha, as above described.

Cylindrical and rectangular basket shapes are also plaited by the Papago, although for light use only, since they are not particularly substantial. Palmea leaf strips make a basket of more or less irregularity of outline and one so quickly and easily plaited that it is not so highly prized as is the more

perfect and laboriously made coiled ware. Plaited baskets serve two functions, both utilitarian: one, to meet a domestic need in general household affairs; the second, to serve as a case to enclose ceremonial objects. Household baskets contain trinkets, sewing articles, clothing, grain, fine seeds, and various odds and ends; ceremonial baskets enclose the numerous medicines of the medicineman or woman, for doctoring the sick and regulating the weather, besides holding the little bags of paint employed in decorating the face and body at ceremonial dances.

The two distinct uses of plaited baskets call for special shapes to fit the dissimilarity in contents, so that baskets for household use are cylindrical in form on a square base, with at times a square-topped overlapping cover (Fig. 21). Although in general outline the baskets hold to the cylindrical form, they often vary slightly from the true cylinder by a gradual drawing in towards the rim (Fig. 21), or this contraction may be followed by an outward curve at the immediate edge (Figs. 22 and 24). The shapes vary considerably in proportion as some are of greater width than height, others of greater height than width, and still others are of equal proportion (Fig. 21). The sizes also cover quite a range, as the dimensions vary from 11 cm. to 40 cm.

The technic is twill plaiting in the rhythm of over three under three, and so constructed as to form parallel bands arranged horizontally, vertically, and in graduated squares (see matting design). The bases are of two styles: (a) the more usual, broken by parallel lines of equal width arranged in graduated squares (Figs. 15b and 23); and (b) the less common cut through the center by a vertical cross (Figs. 15a and 24). The walls of the baskets with base (a) are so constructed that the plaiting results in parallel bands arranged horizontally encircling the basket (Figs. 22); while those with base (b) are so plaited as to result in parallel bands running vertically, although often these vertical bands do not extend to the rim of the basket, but are broken by horizontal lines (Fig. 21). When the base is completed and the wall is to be begun, no additional strips are added, but instead the adjacent strips at each corner are drawn close together and plaited into each other (Fig. 25). The basket edges are all single, as described under mattings. An extra bit of ornament is occasionally constructed with the edge elements, as in Fig. 24, which after having been plaited into the body plaiting are not cut short, as is the usual custom, but turned diagonally toward the upper left and caught under the plaiting.

For ceremonial purposes, the Papago make use of the trunk-shaped basket with a deep overlapping cover, for in this little trunk they place the medicines, paints, etc. It is made particularly for this function, and all the medicine baskets seen on the expedition had been made by the wives,

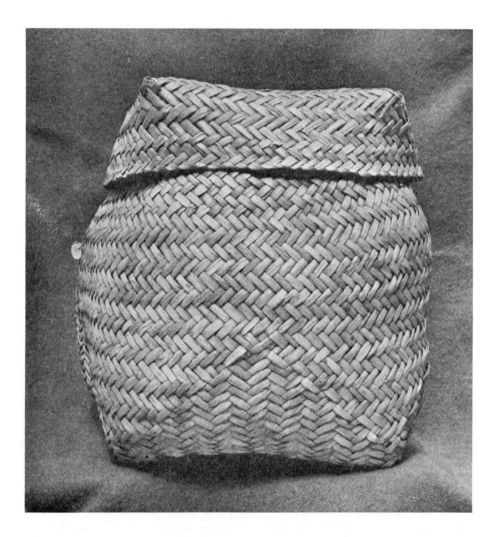

Fig. 21 (50.1–5278).　Plaited Basket with Cover, Pima.

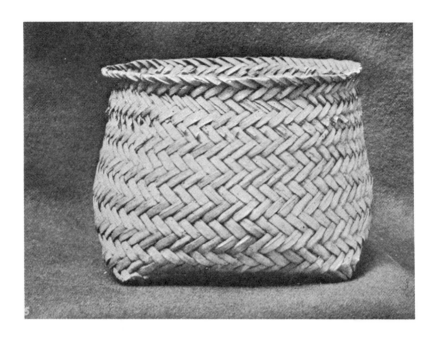

Fig. 22 (50.1–5118). Open Plaited Basket, Papago.

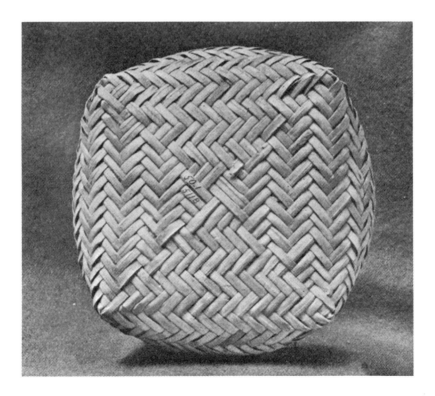

Fig. 23 (50.1–5118). Base of Open Plaited Basket shown in Fig. 22.

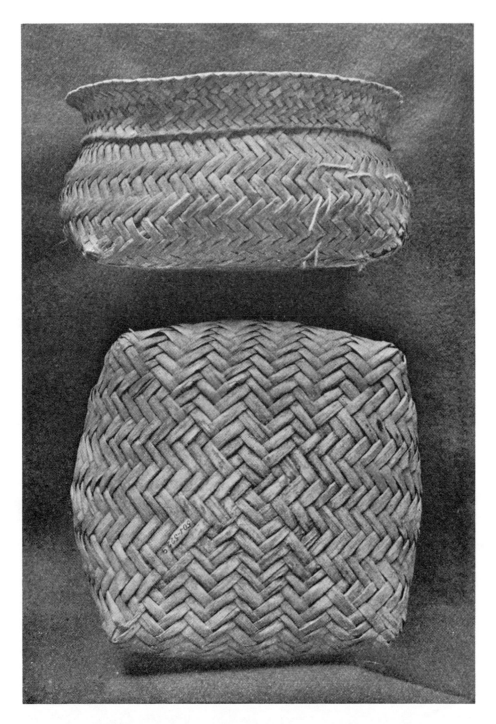

Fig. 24 (50.1–5229). Open Plaited Basket and Base, Papago.

or the mothers of the medicinemen; or by the medicine women themselves. Information was not obtained as to whether other people were allowed to make them, or whether the construction was conducted under different conditions than those during the making of an ordinary household basket. From the oblong base are erected vertical walls for the body; while from a slightly larger oblong top are dropped vertical walls about two-thirds the height of the basket, for a cover. This ample overlapping cover is usually tightly tied on with a string about the center, which tends to give a sag to the middle after short use (Fig. 26). These trunks vary in proportion, some are long and slender, others are short and broad, but their ends in most cases approximate a square. The sizes run from 13 cm. to 86 cm. in length; 7 cm. to 15 cm. in height; and 4 cm. to 21 cm. in depth.

Fig. 25 (50.1–5228). Method of Plaiting Basket Corner.

The technic of the base is twilled plaiting in parallel bands of over three and under three rhythm; the walls are in encircling horizontal bands of the same rhythm; and the cover is like the body of the basket turned upside down. Very occasionally the base and the top of the cover are so plaited as to form two or three squares placed side by side, each enclosing smaller graduated forms of the same shape, such as that in Fig. 15b. The manipulation of the strips to form the corners is the same as when making the corners of the cylindrical household basket, and the finish of the basket is the single edge.

The Museum secured on the expedition six medicine baskets belonging to medicinemen and women of four Papago villages. To these men and women are entrusted the welfare of each particular village, for the Papago believe in their supernatural power to disperse evil spirits which have entered

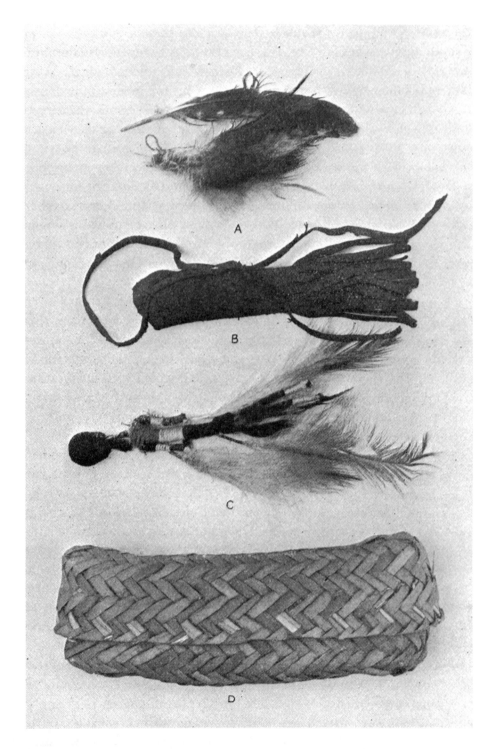

Fig. 26 (50.1–5165). Medicine Basket containing a Little Effigy used to prevent Attacks by the Apache.

into people and caused sickness, and into natural phenomena and caused disturbances; and also that aided by articles of magic, such as are found in these medicine baskets, together with proper ceremonials, the medicine-men and women have the power to avert all evils and invoke all prosperity.

A medicineman's rain-basket with its contents was obtained from the village of Covered Wells. In it are (a) turkey feathers which, with proper chants, bring rain; (b) three sticks of a long stemmed bush with stickers, such as cat's claw, each representing a year the medicineman has practised, and which, with prayer chants, cause rain and also cure rheumatism; (c) a stem of the shrub ash tree with an attached buzzard feather, for emergency cases when there is great need for rain and the preceding charms have proved ineffectual; (d) chicken-hawk feathers, which, when all previous attempts to produce rain have failed, serve as a desperate call for rain for the village, and water and food for the children; (e) deer tail, a cure for headache and also for fever; and (f) extra feathers.

A medicine woman's rain basket was obtained at Little Tucson, for although ceremonial curing is more generally practised by men, there are also medicine women. The contents include (a) feathers for painting the body on ceremonial occasions; (b) three rain-sticks, indicating the woman had been a medicine woman three years, and which with incantations and rhythmic beatings upon the basket drum give rain; (c) a stick with eagle feather, to call forth rain; (d) a tail for curing human illness; and (e) extra loose feathers.

Fig. 26 represents a medicine basket obtained from the medicineman at Santa Rosa village. It contains the magic to protect the Papago from the Apache whom they feared greatly: (a) a little Apache effigy with head of wax and body of string and eagle feathers; (b) a small skin bag with fringed edge, in which to encase the effigy when not in use; and (c) some additional loose feathers.

Another medicine basket was procured from the medicine woman of Little Tucson, from whom the rain basket described above was also obtained. The purpose of its medicine is for protecting an infant from being appropriated by evil spirits, for when (a) the bits of white clay, done up in the small cotton rag, are unwrapped, ground in (b) the shell, and given to the infant, the evil spirits will flee. The powdered clay is administered when the child is about three days old, and at the same time some of it is given to the parents as well. This white clay is also dispensed to young girls as efficacious in protecting them and dispersing all evil spirits. Within the basket is another very small empty one, with no other significance than that it was the first medicine basket this medicine woman made.

A medicineman's basket from San Xavier contains a turtle shell, which

has been converted into a rattle. The magic of this charm had served three generations of medicinemen, for it had been used by the grandfather, and in turn the father of the medicineman from whom it was procured. The turtle had been secured by the grandfather, who cut off its head and legs, and left the shell for ants to clear, before converting it into a rattle. Its efficacy lies in its power over sickness caused by the turtle, such as rheumatism and diseases of old age.

A medicine basket also from San Xavier, although the basket, or the case for the medicine, was not made there but in Santa Rosa, contains owl feathers which have the mastery over certain secret forces in nature, more particularly in this case over sickness and distress due to the owl, the chief among which is fever.

CRUDE COILING.

Another very simple technic found among the Pima is styled crude coil, since it is the crudest type of coiling in existence. Like all ware of this technic it is built spirally, and like foundation coil, it has a foundation element which is united into a solid structure. But the unique thing is that the customary two elements, a foundation and a uniting agent, which are the usual components of foundation coiling, are here merged in one element which performs the work of both. This single member acts as a solid foundation spiral, and also unites its own adjacent segments (Fig. 27). The constituent parts of this one element are twigs of some size, which are added singly and in their natural state still bearing smaller twigs and leaves. The two ends of the twig accomplish the uniting, or binding process, for their stem end clutches into the foundation of the last round of coiling, and the slender leaf end secures itself by winding about the previous twig. A stem end is first inserted on the outside of the previous segment of coiling, and a second stem end is thrust in on the inside a short distance beyond where the first twig entered the previous coil. The continuation of this simple process of inserting one stem on the outside, and the next on the inside, and in each instance winding the leaf end about the previous twig completes this one-element coiled technic.

Besides disagreeing with other coiling of these people in the number of elements which it employs, crude coil also differs in the direction of the movement of the technic. Coiling with two elements advances from right to left, or in a counter-clockwise direction. This would be awkward in crude coiling so we find the technic moving from left to right, or clockwise, as is natural with people who are right-handed. The left hand holds securely the work already completed while the right is free to do the in-

serting of the stem ends and the winding of the leaf ends (Fig. 27). Simple as is the process of constructing crude coil, far from simple is the appearance of the finished technic. One can easily see by Fig. 28, how completely obliterated in a crude mass of twig stems is the actual process. Solving the enigma of its construction from the complicated surface of the finished technic is impossible, for when the leaves have dried and dropped, the tangle of woody stems seem to have grown into this mass. Only after watching an Indian making the coil, or by tearing the technic apart, is its process discernible. So complex is its appearance that one ethnologist, in recording its existence among neighboring desert tribes, thus speaks of baskets constructed with this technic: "These granaries can be called baskets only by courtesy, as they show no distinct weave." [1] Dr. Barrows, however, has looked deeper into its construction in baskets from the Coahuilla, and calls it "a coiled technic of twisted osier withes." [2]

Granaries of crude coiling seem to have had quite a distribution along the streams of this desert quarter before white men disturbed the culture of the red men. They have been found in the cliff-dwelling caves of southwestern Colorado, and are used today upon the roof by the Pima and Cocopa,[3] upon platforms by the Pima and Mohave,[4] Coahuilla[3]; and upon the ground by the Papago, in the few instances found. The forms of these granaries vary but slightly, except in the hive shapes of the Papago, since they hold to the cylindrical as with the Mohave; or to the cylindrical with a spreading toward the base as with the Coahuilla; or to the cylindrical with a spreading toward the top as with the Pima.

These great nest-shaped structures, roofed with overhanging twigs, perched upon many of the hut roofs are a novel sight to the traveler as he enters a Pima village (Fig. 29b), although very occasionally as already said, they are on raised platforms (Fig. 30). These structures, not only resemble a huge nest in form, but also in texture, for they seem put together much as a bird builds a nest; in reality they are immense baskets, termed caches, and constructed of the coiling previously described, the crudest coiled basketry now known. They are baskets for storage, for the preservation of the crops of wheat and corn, as well as mesquite beans in the pod. To reach the granaries on the roof a ladder must be used, and it stands ready at all times against the wall of the hut. The women must climb this ladder each time the family needs a fresh supply of grain or beans and also in time of harvest,

[1] Kroeber, A. L., "Ethnography of the Coahuilla Indians," *University of California Pub.,* Vol. 8, No. 2, June 1908, 42, 43.

[2] "Ethno-Botany of the Coahuilla Indians of Southern California," *University of Chicago Press,* Chicago, 1900, 52, 53.

[3] Barrows, *ibid.,* 52, 53.

[4] Kroeber, *ibid.,* 42, 43.

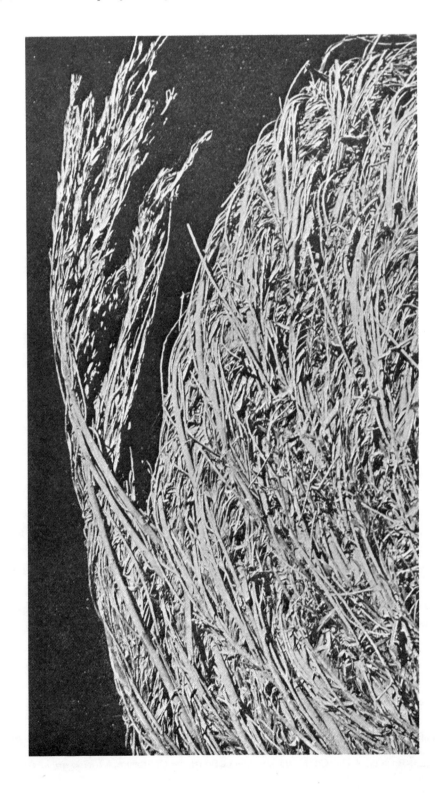

Fig. 27. Technic of Crude Coil.

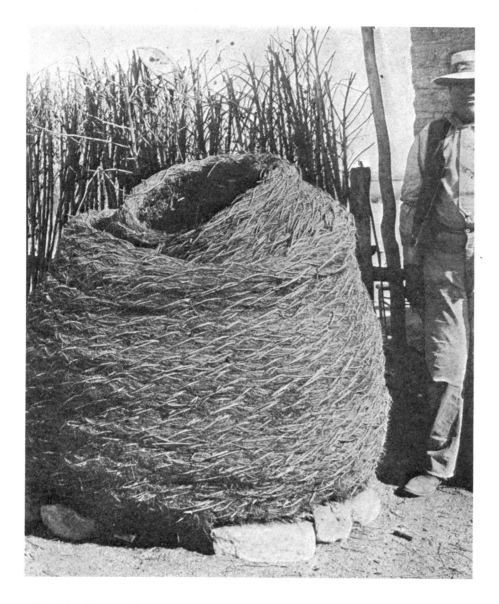

Fig. 28. Papago Granary of Crude Coiling, (United States National Museum photograph).

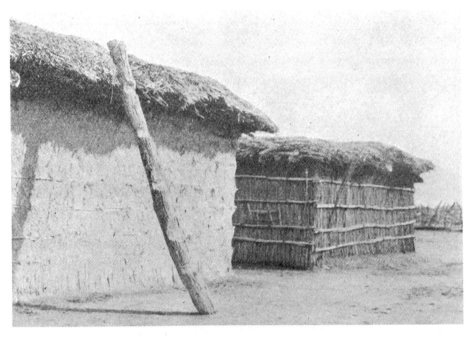

a

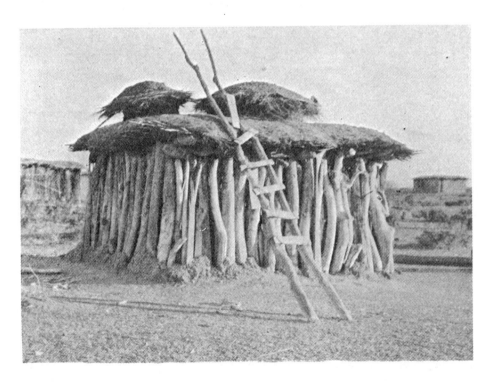

b

Fig. 29. *a* Old-time Ladder for filling Pima Granary on House Top; *b*, Storage House with Two Granaries and Modern Ladder.

when the winter's supply is hoisted to these granaries for storage upon the hut roof. Present-day ladders have the two upright beams of small cotton-wood trunks, with rounds, or slats, of cactus rib, (Fig. 29b). Old ladders, numerous throughout the Southwest in years gone by, but seldom met with now, are of a large cottonwood tree trunk, notched for steps (Fig. 29a).

For making this rustic technic, the Pima and Papago find growing along the few streams of their arid land the slender, pliable, but not very durable arrowbush, *Plucea borealis.* Its stems in olden days furnished the wood for

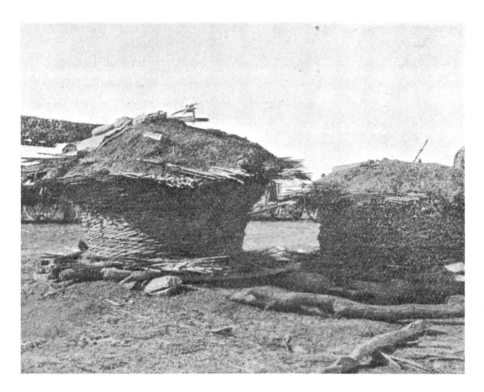

Fig. 30. Granaries on Platforms.

arrows, and at the present time builds the hut of the Pima as well as this basket granary of crude coiling. For this purpose the stem of the arrowbush is broken near the ground and used immediately while still fresh and pliant. Since that section of Papagueria which is in Arizona has but one river, arrowbush is not as plentiful as with the Pima, so crude coil is very little practised, and when it is, another similar material, likewise termed "shamt" is frequently employed. For the same technic the Coahuilla use willow,[1] the Mohave arrowbush.[2]

[1] Barrows, *ibid.*, 52.
[2] Pacific railroad survey itinerary, p. 115.

The Pima storage bin is built without a base for the roof, or platform, upon which it rests usually serves this purpose, although a layer of arrow-bush is frequently spread on the spot where it is to stand. The granary is covered with a roof, slightly raised in low cone shape at the center and gently sloping to the overhanging rim. Like the body, its roof is of arrow-bush twigs, but so placed as to radiate from the center, and these are laid upon a square of cloth, or a piece of old grain basket of coarse coiling, to keep the contents free from dropping leaves of the arrowbush, and the dirt which is piled loosely on top of the granary cover. Granaries vary consider-ably in size, but the average height is from 40 cm. to 50 cm., and the diameter about 1 m.

The Pima nest-shaped storage basket is not used by the Papago. The very few granaries of crude coiling made by them are shaped like a hive, or a barrel with incurving top (Fig. 28). Its base is usually a coiling of finer material: willow, cottonwood, or more frequently beargrass, since arrowbush is too stiff a material to work into the close rounds of the circular base. The Papago barrel-shaped bin is never found on the hut roof, but stands on a few boards, or stones, to lift it from the ground; neither is it roofed over, but its opening is covered with an old tray basket, or a piece of canvas. At times, it reaches the height of a man's shoulder, but more usually is slightly lower. As these baskets for storage are always found out-of-doors, and never within the hut or the storage shed, they must weather the climate, which in this region, however, is not a severe one except for heat, wind, and dirt. Even with these conditions some granaries will last two years, but it seems a more frequent custom to construct a new one each twelve months, and this is not a laborious task as one can be easily made in a day.

For constructing crude coil, no tools are required further than something for cutting down the material. As before stated, the Pima granary is without base, so that the first coil of the wall will be the beginning of the granary. This is started by making a bundle of twigs about half the size of a man's wrist into a ring, with a diameter equal to that of the proposed base. The bunch of twigs forming the ring are bound over and over with a slender twig, for to this ring will be attached the first row of coiling, since into it the stem ends of the twigs are inserted. First the stem end of a twig is thrust into the outside of the ring in such a manner that the stem will follow the top edge of the ring, with its leaf end pointing toward the right. The stem end of a second twig is then thrust into the ring on the inside about two inches to the right of where the first stem end entered the begin-ning ring, with its leaf end pointing to the right as before, when it is wrapped about the first twig. The stem end of a third twig is then thrust on the outside of the beginning ring, two inches to the right of the point where

the second twig entered the beginning ring. The leaf end of this twig points
to the right, and wraps about the first and second twigs which by this time
make a coil of some size. The stem end of the fourth twig is pushed into
the beginning ring on the inside and its leaf end wrapped about the previ-
ously twisted twigs (Fig. 27). So the process continues until there remains
no more space on the beginning ring for the insertion of more twig ends,
when the first row of coiling just completed must serve as a ring for the
insertion of new twigs. The stem ends are pushed into this as before,
alternating first one on the outside and then another on the inside; and this
continues round after round, until the granary wall has reached the pro-
posed height, when as a finish the last leaf end is bound with a twig, or string,
to the previous row of coiling.

COARSE COILING.

A great step in advance over the last unique coiling of one element with a
double function, is another more general type of foundation coil which is
practised by both Papago and Pima. It is a coarse coil with two members:
a foundation element, or passive spiral; and a binding element, or active
spiral which unites the segments of the passive foundation (Figs. 31 to 33).

The direction in the movement of the technic, that of the foundation
and its accompanying binder, differs from crude coil, since it moves toward
the left, or counter-clockwise. This is the natural movement for coiling
of two elements with multiple foundation, for right-handed people, since
the left hand supplies fresh material for the foundation, and also holds it
in place while the right manipulates the binding element by passing it
toward the left over the already prepared foundation. Both tribes work
baskets from the outside, as well as from the inside, depending entirely
upon which surface they wish to give the smoother finish, so that before
determining the direction of a technic it is necessary to find the right side
of the technic.

In addition to the general movement of both foundation and binder
in the large spiral about the basket, the binding element has a secondary
movement which unites the adjacent rounds of the technic by means of a
smaller spiral. This smaller secondary spiral moves about the foundation
coil in process and punctures the upper edge of the foundation coil in the
previous round, binding the round in process securely to it. The style of
this smaller spiral designates the particular type of coiling, which in this
case is a plain spiral and not twisted, interlaced, or looped as in other types;
so the technic is termed spiral coiling (Figs. 31–35). The segments of the

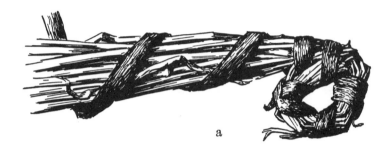

a

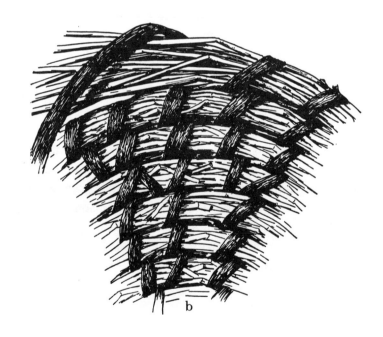

b

Fig. 31 (50.1–5274, 5275). Coarse Coiling, Pima: *a*, beginning; *b*, base.

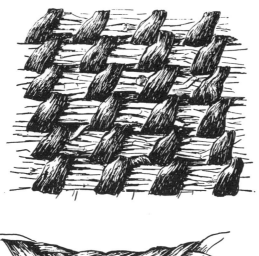

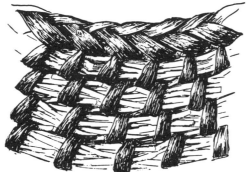

Fig. 32 (50.1–5276). Pima Coarse Coiling showing Side Wall and Edge.

Fig. 33 (50.1–5192a). Papago Coarse Coiling.

binder are not placed in juxtaposition to each other in this coarse coil, but are spread apart in a distended spiral, thus allowing the foundation to show between, and resulting in a more open texture than that of smaller baskets, which are constructed of finer materials, and for this reason it is commonly termed "open coiling." In coiled basketry the foundation element may also show a diversity in composition, which, however, is of minor significance as belonging to an inner member and so receives the last consideration. Here it is composed of a number of splints and in consequence is called "multiple foundation" (Figs. 31–35).

Coarse coil constructs a second style of granary, but one which is not found on the house roofs and outside platforms, as are the nest and barrel shapes of crude coiling, for this storage bin is not exposed to the weather but kept indoors; when families are poor, it is placed in a corner of the hut, but if they are more prosperous, it is housed in the storage shed. Like the crude granary, it stores wheat and corn, and in addition may hold fine seeds, and shelled beans of several varieties. The Indians are loath to part with either of their storage baskets, for within them much of the family food supply is deposited, when nature has ceased for a season to yield the fresh foods (Figs. 30, 35). If the year has not been an exceptionally dry one, a Papago or Pima storage shed after the harvest season has past is an enviable sight. On its walls are basket materials, martynia, willow bark, willow splints; standing in a corner are beargrass, cat-tail, wheat straw; from beam to beam hang peppers, red and green; while on the ground are squashes, gourds, and great basket granaries full and running over with grains, beans, and various seeds. All these assure comfort to the family during the season when nothing is supplied by the fields. The preservation of the smaller foods required suitable receptacles, and these coiled granaries have supplied this need and so are greatly prized.

In outward appearance this second storage bin differs greatly from the crude type with its loose ragged structure described above, for here the walls are more substantially built. Just how long it will last before falling to pieces, depends upon the place it is kept, the care it receives during use, and the excellence in workmanship when constructed. Some storehouses are crudely built, open to the dust and dirt blown in by desert winds; some Indians are heedless in handling and filling their storage baskets, and others careless in the compactness of its construction, for at times the binding element is loosely coiled, with great spaces left between the segments of the binding spiral. However, the bin commonly has enduring resistance for about eight or ten years of continuous service.

This is not an uncommon storage basket among peoples of lower culture. Similar baskets, both in shape and technic, are found in many parts of Africa

and a number of localities in America. The largest bins of the Papago and the Pima correspond in being globular in form; but the smaller bins differ, as the Pima are bell-shaped, with a flat base and obliquely straighter wall (Fig. 34), and the Papago barrel-shaped, with a smaller base and more rounding wall (Fig. 35). These bins are covered with a lid especially made for them, or with an old basket bottom of finer coiled ware. After they are filled these lids are sealed with mud; in fact, the whole bin may be completely covered.

There is great variety in the size of both Papago and Pima shapes, averaging from $\frac{1}{2}$ to $1\frac{1}{2}$ meters in height, but in the large spherical bins of both tribes they reach 2 meters in height and about the same diameter. These great globular granaries must be constructed within the hut or storage shed where they remain, since they are too bulky to pass through the door, or storage house opening after being made. They are also too large to be constructed by the usual method from the outside, but must be made from within, when the worker gets into the basket as seen in Fig. 39.

The materials for coarse coil differ in the two tribes: the Pima foundation is wheat straw (*Triticum vulge*); and the Papago beargrass (*Nolina erumpems*), wheat straw and ocatillo (*Fouquicria splendens*). The Pima binding materials are barks of the willow (*Salix nigra*), mesquite (*Prosopis veluntina*), *Acacia constricta*, and a few other trees; those of the Papago are leaves of sotol (*Yucca elata*) and mesquite bark. Wheat straw is procured from the fields after the harvest and needs no preparation. Beargrass is gathered from the foothills in summer, its method of collection and preparation are fully described in the chapter on close coil. Willow bark, mesquite bark, and other barks are stripped from the standing tree, and only a little is removed from each, that the loss of the bark may not injure the tree's growth. Bark must be used while still green, or if allowed to dry after cutting, it must be well soaked before it is pliable enough for use. Sotol is found on the upper mesas, its process of gathering and preparation will be found under close soil (p. 190).

Like all basket work of the Papago and Pima with the exception of cradle-making, these bins are constructed by the women; and as in all foundation coiling they are aided in their construction by two tools, a large butcher knife, or other strong blade, and an awl. This last is made of hard wood, either *Sarcobatus vermicularis*, or *Acaca constricta*, and whittled into shape by the women. The difference in general appearance of the Papago and Pima baskets of this type (Figs. 34–35), comes from two causes: a difference in material, and also one of care in setting the segments of the binding spiral (Figs. 32–33). The Papago foundation materials are rough and uneven, and equally so are the binding materials, while the Pima

foundation of wheat straw and the binder of willow bark are more manage-
able. This in addition to greater care in making, gives a Pima bin which
is more perfect in outline, more solid in build, with the rounds of coiling
more evenly and smoothly bound (Fig. 34, Figs. 31–32).

The coarse coiled granary is usually not made until emergency calls for
it, when as the illustrations of a Pima at work show, the woman supplies
this need. She selects a bunch of wheat straw about the size of a man's
thumb, and wraps it with a strip of bark for about 4 inches (Fig. 36a), when

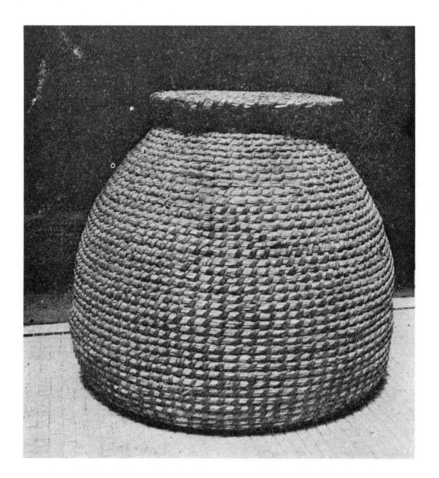

Fig. 34 (50.1–5276). Pima Granary of Coarse Coiling.

the wrapped bunch is bent to form a small ring, or circle, for the center of
the base of the granary (Fig. 36b), and the binding element passed through
the center of the circle a couple of times (Fig. 37a), to bind the ring securely
(Figs. 31a, 37b). Regular coiling now begins by passing the foundation
coil around and around this small circular beginning, while its accompanying
binding element wraps about the round of foundation coil in process and

catches into the top edge of the coil below (Fig. 31b), through the hole already pierced by the wooden awl (Fig. 38ab).

This continues until the base is the desired size, when the new round of coiling is so placed as to start the wall of the basket upward. The position of the new round of coiling in relation to the base, decides the prospective

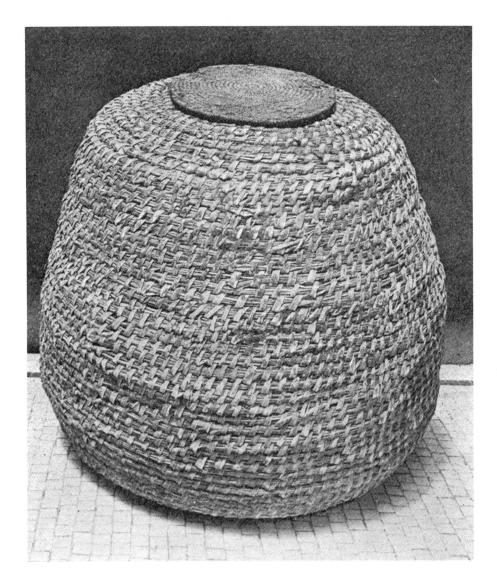

Fig. 35 (50.1–5192). Papago Granary of Coarse Coiling.

curve of the wall, for in the setting of each new foundation round of the wall, lies the secret of shaping the outline of the basket, since it determines whether the form is to be globular, barrel, or bell-shaped. So without decoration, other than a braiding of the binding element on the final round

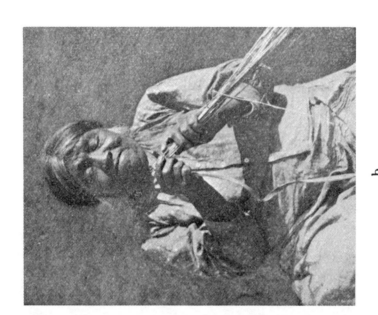

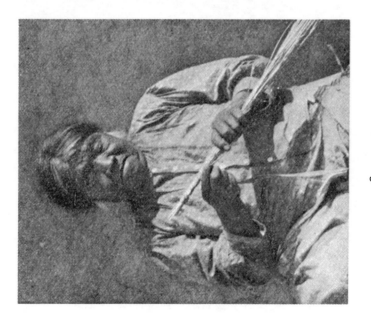

Fig. 36. Pima Basket Maker beginning Coarse Coiling: *a*, wrapping the foundation element; *b*, shaping the center ring to which the first coil is bound.

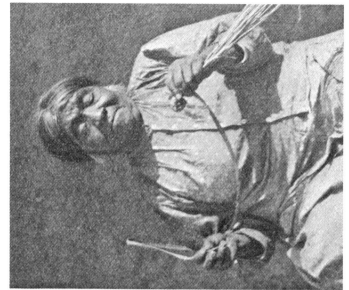

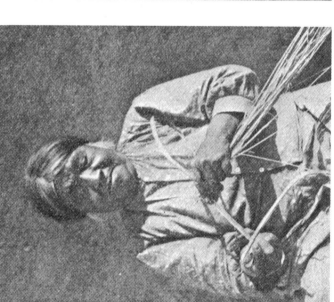

b

a

Fig. 37. Pima Basket Maker: *a*, binding the center ring; *b*, center ring completed.

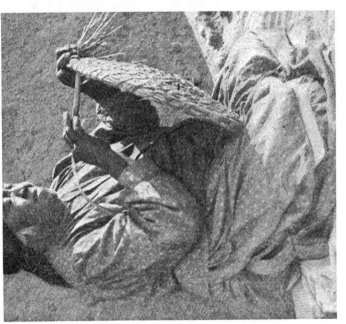

Fig. 38. Pima Basket Maker: *a*, showing use of large wooden awl; *b*, pushing through the binding element.

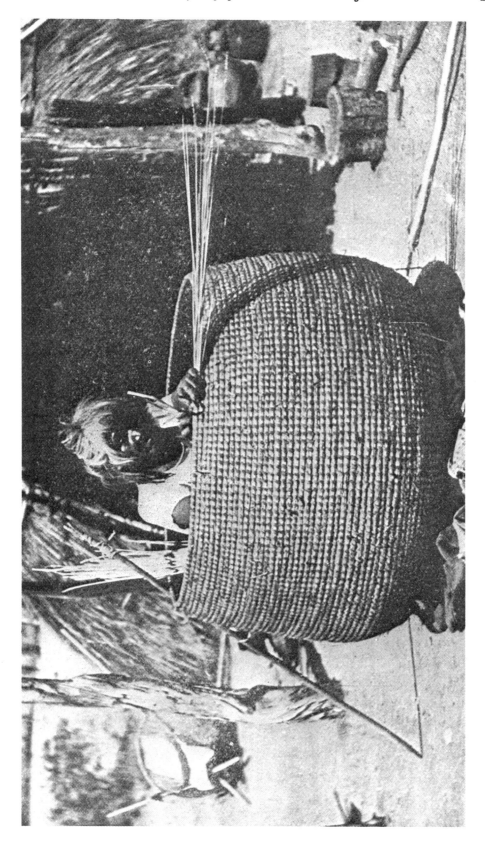

Fig. 39. Pima Basket Maker completing a Large Granary. (Photograph by Putnam and Valentine, Los Angeles, Cal.)

of the foundation coil (Fig. 32a), whose purpose, in reality, is as much to give strength to the edge as to decorate, the granary is completed, and its beauty consists entirely in careful shaping and evenness of construction. At times, these bins are built with a double foundation coil, that is, two coils are placed one above the other and bound on together. While this method completes a basket more quickly, it produces a structure far less firm and strong, so that the single foundation coil is more frequently resorted to.

Close Coiling.

The best known basketry of these tribes is close coil, with conventional fret designs in black. It is a more perfect coiling than the last, with its thick foundation and binder of spreading segments exposing the first element, for it has a narrower foundation and a more slender binder of closely set segments, completely covering the groundwork. Otherwise than in size of the two elements and in the set of the binder segments the two seemingly different technics are identical. Obviously this is a fully developed foundation coil of two elements, the foundation and the binder, which jointly move spirally in a counter-clockwise direction from center to rim; while the foundation, a passive spiral, constitutes the groundwork of the technic, and supports the active binding element. This last element follows the foundation in its general movement about the basket, and also revolves in a smaller secondary spiral as it encircles the round of the foundation in process and unites it to that of the previous round by catching into its upper edge between the segments of the binder, without interlocking with them. This smaller secondary spiral is a plain one, which during the process of uniting completely covers the multiple foundation (Fig. 58). Close coiling is the most substantial basket technic of these people, serving in places where great strength and durability are required, together with closeness and evenness of texture, as in the milling industry, the preparation of foods, the transportation of fine grains and seeds, as well as the transporting and raising of water, which was done in the old time water-tight well-buckets and bottle baskets of the Papago.

The Indian villages of this arid land, like the parched vegetation, appear to have sprung out of the brown earth, for when seen from a distance, the dust-covered huts of twigs and mud seem to be a part of the desert itself. Upon coming nearer, however, one discovers that these circular and rectangular shapes are the crude works of man; that here human life is sheltered, and that many of the processes for providing food and clothing are everywhere evident, since signs of these are seen scattered about in black-

ened cooking pots, sticks of charred wood, old cans and bits of rag. In the shade of a rustic arbor, built of tree trunks and roofed over with twigs and mud, stands the water olla on its forked tree-stump, for at this fount the hot and dusty inhabitant of the desert finds cool refreshing drink. Before the door are further indications of domestic activity, an old basket tray charred by hot coals, another stained with red peppers, and to the left a battered adobe oven; while nearby on the ground rests the flat stone-mill, the metate, its supplying wheat tray at one side, its receiving flour tray at the end, although the woman grinder has vanished, for frightened at the approach of strangers, she has hastily fled from her work and escaped into the hut. Beyond, squatting upon the ground, is a neighbor potter plying her art; while far off among the distant mesquite trees is another woman returning from the fields laden with her basket bowl upon her head. Of these busy scenes the ones which interest us most at this point, are those where baskets play an important part, the coiled bowls and trays, which minister to so many Papago and Pima wants. Their varied contents can best be accommodated in these two forms, each shape with a distinct function, though occasionally the tray performs the duty of the bowl, and the bowl that of the tray. Other shapes, the olla and waste-basket forms seen in curio shops, are trade baskets made for white man's use and not for the Indian's.

The primary function of the basket bowl is that of transportation, its secondary use that of a temporary receptacle, (Figs. 42–43). Like the olla water jar, during carrying it is balanced on the head without the aid of the hands, but unlike the olla, at the present day it transports dry produce only, fruits of the cactus, vegetables, grains, berries, and small seeds, while formerly it was employed as a basket for watering horses, drawing water from the well, and similar purposes. Isaac Whittemore in 1893 tells of Pima women removing dirt from irrigation ditches in basket bowls.[1] Still earlier, some thirty or forty years ago, white settlers in Papagueria remembered seeing water carried in two water jar baskets, thrown over the saddle horse on either side, or attached to the saddle itself. The Papago still do much gathering in the basket bowl, but white settlers have located near the Pima villages, thus bringing markets in such close proximity as to discourage much of the old-time gathering of wild things. Besides, for a number of years the United States Government has donated a wagon to each

[1] "They had not pails or vessels of wood, but were not slow to invent. They therefore took willows which grow in abundance along the river, and a reed, and strip the bark, then very adroitly split these with their teeth, and wove them so closely as to hold water. This they accomplished by means of needles or thorns of cactus. They used these baskets while digging small ditches, the women filling them with earth and carrying them up the bank." (Isaac T. Whittemore, "Among the Pima," p. 53, Albany, N. Y., 1893).

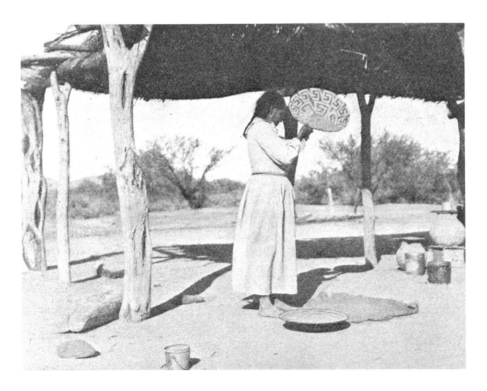

Fig. 40.

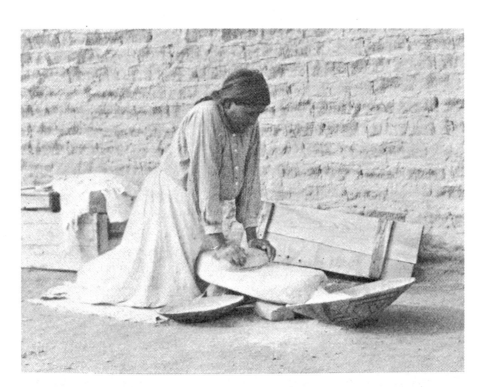

Fig. 41.

Fig. 40. Pima Woman winnowing Wheat. The wheat is poured upon a matting and the wind carries away the chaff.

Fig. 41. Pima Woman grinding Wheat. From a basket tray at her side she places a handful of wheat on the metate and after grinding with the muller, pushes the ground flour into a second basket.

Indian family where the man builds an adobe house and cuts his hair. The possession of these wagons has brought the markets within still easier reach, so that this, together with the fact that many of the younger Pima laugh at those who continue to journey for wild things, has lessened the use of the bowl for transportation.

The function of the tray is not that of storage, or transportation, but household service, where it ministers most efficiently (Figs. 40–41). Only on ceremonial occasions is it employed at the present time, as an eating dish, when the small water-tight tray of the Papàgo medicineman is called into service, both as a drinking cup and a piñole dish, when on expeditions to the sea for sacred salt, and when curing the sick (Fig. 60f). The tray is the most frequently used basket of these tribes, aiding in the preparation of all kinds of foods, and since few of these are eaten raw, it is a most constant helper in their culinary work, taking the place of white man's pan, bowl, and plate, for the cutting up and getting ready for cooking squashes, pumpkins, roots, beans, and other vegetables; different kinds of meats; fruits, berries, seeds, and cereals. This continual use of the basket tray has greatly endeared it to the Indian woman, who handles it with loving care, knowing how repeatedly it has ministered to her wants. How many harvests have come and gone through which it has served her; what a great variety of foods it has protectingly held for her; how many meals it has helped prepare for her hungry household!

Wheat (pelca, or pelka) has been a staple food with the Papago and Pima since introduced by the white man many years ago. In prosperous seasons the Pima do not mill their wheat, they exchange it for flour; but when times are hard they return to their old custom of milling the wheat. Few of the Papago buy flour even in prosperous years, but continue the old methods of milling. For this the tray serves in two distinct processes, in the winnowing and in the grinding. Wheat is winnowed in two ways: it may be tossed in the tray, or poured from it onto a canvas spread upon the ground (Fig. 40); in either case, the wind acts as the agent for disposing of the chaff, for the winnower so places herself that it will be carried off in this way. When following the first method, the woman sits on the ground and lightly and deftly tosses the wheat kernels which have been previously loosened from their hulls. At times between tossing she gives them a hard rub on the base of the tray to loosen any hull that still adheres to the kernel; then she continues the tossing without losing a grain over the rim, while the wind takes care of the chaff. During the second method of winnowing the woman stands while she pours the wheat from her tray basket upon the square of canvas, and the hulled kernels fall to the ground, the wind disposing of the chaff (Fig. 40).

In flour making the grinding process follows that of winnowing. This is done on the heavy stone metate, (Fig. 41), a flat rectangular stone with a slight dip on its upper surface. It is usually found standing near at hand just outside the door, or under the rustic arbor, or if inside, within the storage shed, or possibly, but more rarely, within the house itself. During grinding, the metate may rest flat upon the ground without a prop, but more commonly it is tilted a bit at the front edge on a small stone. The wheat is ground upon its surface by means of a flat rectangular muller stone rubbed across it; and it is a hard grind the Indian woman must give her grain to turn it into flour. From the supply tray at her right, she puts a handful of unground grain upon the metate, and rubs the muller over it, until it is very fine, when she pushes the ground flour over the back edge into the flour tray beyond. Incidentally, a minor process enters into milling before the grinding, that of cleaning the wheat, as it must be thoroughly looked over and freed of stray seeds and bits of dirt that may have fallen in among the kernels of wheat. A deeper tray is used for this, if the family is provided with trays of varying depths, since there is less danger of spilling the grain as it is pushed about with the hands, or rocked from side to side, that all the stray specks and dirt may be found.

Ground wheat, corn, and other seeds are cooked in a number of ways: baked in loaves, or tortillas, fried in suet; or boiled in soups and gruels. In most of these instances, the basket tray serves as the mixing dish, holds the dough while waiting to be placed on the fire, and receives the food when cooked and ready for serving. Only one instance was reported where in former times the tray served as an eating plate for a mixture of corn and beans similar to succotash.

Another grinding process is carried on not by rubbing, but by crushing in a wooden mortar constructed of a cottonwood stump, when either a vertical section is hollowed out at one end and the stump stood on the other end (Fig. 42); or a horizontal section is dug out on one side, or around a knot hole (Fig. 75a). The size of the stone pestle for crushing, varies from a very light weight to one of such heft as to require both hands in the lifting, since it is suited to the seeds to be ground. The food most frequently so crushed, or ground, is the mesquite bean; although other beans and seeds are put through the same process, during which, as in grinding on the metate, both supplying and receiving baskets are present (Fig. 42).

For parching wheat with live coals, a pan, or a wooden tray, is now ordinarily employed, but when neither is handy, the Indian woman finds for this purpose a much-worn basket tray, as is attested by the scorched and charred linings of numbers of these old trays, and this, no doubt, was the old custom before civilization brought the pan and the wooden tray.

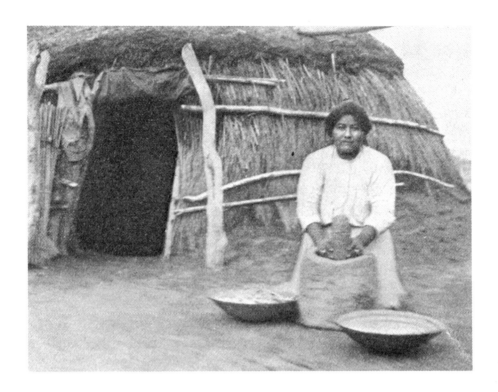

Fig. 42.

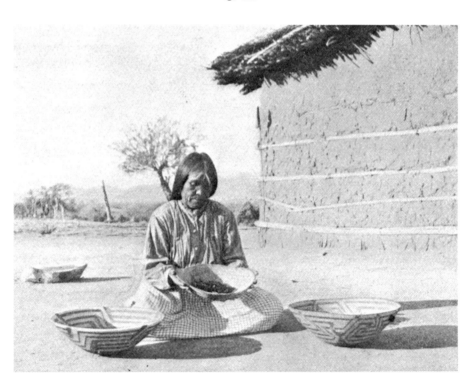

Fig. 43.

Fig. 42. Grinding Mesquite Beans in a Wooden Mortar made from a Cottonwood Stump.

Fig. 43. Pima Woman parching Wheat with Live Coals; one bowl contains unparched and the other parched wheat.

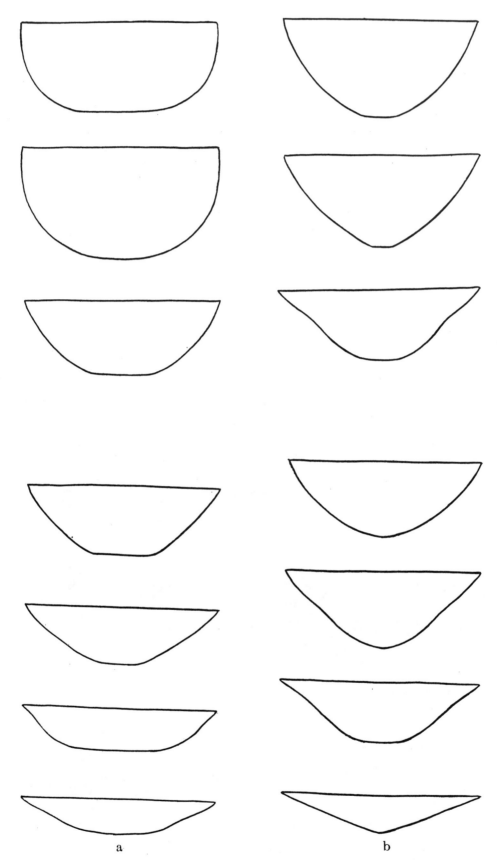

Fig. 44. Forms of Papago and Pima Bowls and Trays: *a*, Papago; *b*, Pima.

For the parching, live coals are raked into the tray and the grain thrown in on top, when a series of tosses brings the lighter coals to the top, and sends the wheat to the bottom; continued tossing keeps the two in motion, and a puff of breath blows the ashes away. When the process is completed the ever-present basket receives the parched grain as did a similar utensil furnish the unparched grain (Fig. 43). Wheat is also roasted in a bit of broken pottery, over the live coals of the open fire within the hut.

Trays of close coiling frequently take the place of covers for the large grain bins of coarse coiling and for pottery ollas. It is seldom a new tray acts in this capacity, more usually it is the impaired trays, or the broken-out base of some old bowl or tray which serves the purpose of a cover.

In addition to the utilitarian functions of the basket tray, it has another, a ceremonial use, for turned wrong side up any hard firm tray of sufficient size, such as are in common household use, may be called to act as a drum upon ceremonial occasions, either at dances, or when the medicineman is doctoring the sick or modifying the weather conditions. At these ceremonies, the medicineman accompanies his songs with a beating on the basket drum in rhythm either with the hand, or a stick.

Besides baskets for their own use, the Papago make a basket for sale of sotol (*Yucca elata*) upon a foundation of beargrass (Figs. 67 and 69). These are not so strong or smooth as those made of "tree material" for household use, and are only called into domestic service when the Indian woman finds all her baskets of "tree material" are otherwise employed. The sotol basket is disposed of rapidly to curio dealers, missionaries, and others interested in helping the Indians financially. From this extensive distribution of the sale basket has come the false report that Papago coiled baskets are constructed exclusively of sotol.

In proportion and general contour Papago bowls are broad, globular, flat based forms (Figs. 44 and 59d), whose qualities of shape harmonize with their heavy, solid, unyielding construction, which when function requires are water-tight (Fig. 59b). As would be expected, the wall is thick (Fig. 59b and 65c) and hard, and built with full, well-rounded curves, and a soft edge, tending at times to curve inward (Figs. 59b, d). The Papago trays follow the same plan as the bowls, although the slight height of the tray form, excludes some of the qualities shown in the bowls (Fig. 44). Papago water basket jars, now no longer used, were tall, slender, bottle shapes with an incurving neck. In general proportion and shape, Pima bowls are taller and more oval than Papago bowls, with a narrow curved base (Figs. 63a, 65d, 44). Their build is lighter, more pliable, and never water-tight; their contour more subtle in line, with sweeping upspringing curves; the wall thin and springy; the edge sharp and clean cut, with no

tendency toward incurving. As with the Papago, the tray forms of the Pima have similar characteristics to the Pima bowls (Fig. 44).

In size, Papago bowls range from 40 cm. to 50 cm. in diameter, and 18 cm. to 22 cm. in depth (Fig. 44); the deep trays from 40 cm. to 50 cm. in diameter and 11 cm. to 16 cm. in depth (Fig. 44); and the shallow trays from 32 cm. to 40 cm. in diameter and 4 cm. to 7 cm. in depth (Fig. 44). Pima bowls are slightly taller than those of the Papago (Fig. 44) and their trays are slightly broader (Fig. 44).

The material for the foundation element of the Papago is beargrass (*Nolina erumpems*), although Spanish bayonet (*Yucca baccata*) is substituted as a makeshift when beargrass cannot be obtained; the foundation element of the Pima is cat-tail (*Typha angustifolio*), and when this is lacking the poorer parts of old cottonwood twigs (*Populus fremontii*). Summer is the season for harvesting beargrass, when the women generally go for it in groups, at the present time in wagons, but formerly on foot. Even when the trip is taken by wagon, an entire day is none too long for the journey, so when the time arrives for a particular group of friends to gather this basket material in the foothills, they must get an early morning start. Beargrass grows in great bunches from 30 cm. to 60 cm. in diameter, and from 60 cm. to 90 cm. in height. In the center of these clusters the grass stands erect, but around the edge it is dry and bends to the ground; so this outer portion is rejected by the gatherers and only the center cut away with axes and large butcher knives. Each woman collects for herself as much as she needs, some selecting with care the material in the best condition, others gathering more carelessly; when the beargrass is carried home it is laid on the ground to dry in the sun for four or five days, but it must be taken in during showers. When needed for basketry it is taken without moistening, and split by the teeth, fingers, finger-nails, or at times a knife, and worked into the basket, dry. Spanish bayonet is employed by the Papago when beargrass is not at hand; its preparation and use does not differ from that of the latter material. A third material for the foundation was reported by one woman in Little Tucson who remembered the Papago years ago using a "tree material," but what this tree was she did not know. Cat-tail is gathered by the Pima in a manner similar to that of beargrass, although it is found nearer the villages, so the journey is not so long. As with the Papago, these harvestings are social affairs, where the women take their lunches and spend the day. The hollow stem of the plant is the part needed for the foundation element, which is split dry, and worked into the basket without moistening (Fig. 48). In districts where the Pima cannot obtain cat-tail they substitute a foundation material which constructs a coarser basket than the cattail, that of finely split twigs of cottonwood, but only those which are too

old and brittle to serve as a binder material, since pliable twigs are too precious to be used in this way.

The materials for the binding element are the same in both tribes, except on Papago sale baskets and a few for home use. These materials, with this exception, are splints of willow (*Salix nigra*), and of cottonwood (*Populus fremontii*) found mostly in the Pima habitat, and splints from the seedpods of martynia (*Martynia probosidea*) found in both habitats. To these is added a fourth material for the exceptional Papago baskets, the sotol (*Yucca elata*). Spring is the season for gathering twigs, the willows (Fig. 45), and the cottonwood, autumn is the time of year when martynia is ripe (Fig. 46); and summer is the harvest time for sotol.

When the first green leaves appear in the spring, the Indian woman goes out to cut the willow twigs from the trees which border the few small streams, or the dry stream beds. Around the foot of the tree, and on the trunk, where a bunch of fresh growth is sent up, she finds the pliable young twigs suitable for basket work and although the first she can easily obtain, for the last she must climb. The twigs are cut with a sharp knife, tied into bundles and carried home upon the head, or in the kiaha on the back, where they are immediately cleared of the bark, as otherwise it will adhere to the wood. In olden days, the Indians loosened it from the wood by boiling, but that practice has long since been abandoned. In stripping off the bark, the start may be made from an end of the twig, or the teeth may lift the bark midway between the ends, and the inserted thumbs then peel it off to the extremities of the twig. This removes one half the bark, another such stripping clears the other side of the twig, and the ends of these barkless twigs are split in two by the teeth and stripped apart with the fingers. For a finer binding element the strips are again split, after which they are rolled into coils ready for barter or storage (Fig. 45). Before using for basket-making, a thorough soaking is necessary, but only of a few splints at a time. Cottonwood splints are gathered, prepared, and used as those of the willow, and yield a whiter, less smooth and less durable binding element than the willow.

Sotol is a yucca from the higher mesas. Its long narrow leaves, radiating from the central stem, are used for the binding element on Papago sale baskets. Only the young, tender, inside leaves at the center of the plant are suitable and are grasped and pulled out with the hands, stripped immediately of their stringy edges, and split down the center midrib with the basket awl, before being spread on the ground for two or three days to dry. When wanted for coiling, a few strips are soaked in hot water for a short time, and then wrapped in a cloth to keep damp, but before using, the midrib is shaved off with a knife by holding the strip taut between the teeth and the left hand while using the knife with the right.

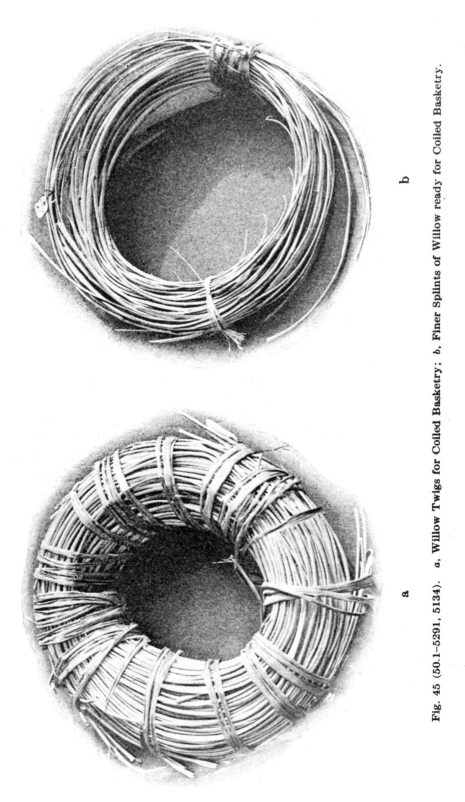

Fig. 45 (50.1–5291, 5134). *a,* Willow Twigs for Coiled Basketry; *b,* Finer Splints of Willow ready for Coiled Basketry.

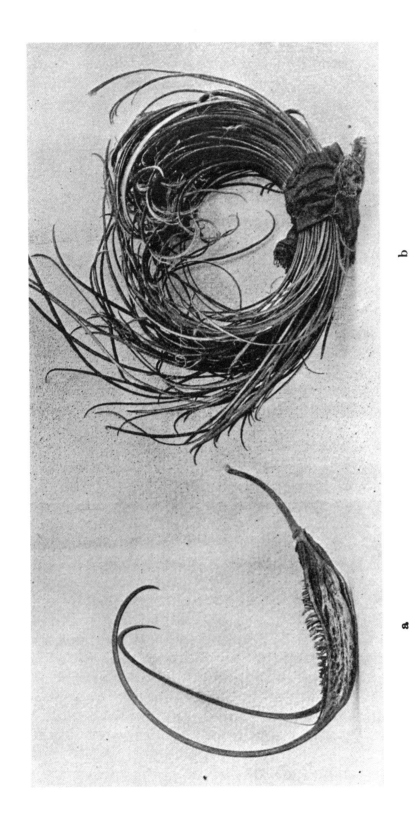

b

a

Fig. 46 (50.1–5139, 5137). *a*, Martynia Pod; *b*, Martynia Splints for Black Designs on Coiled Basketry.

Martino, popularly called martynia, and also devil's claw, is the black material employed for designs. It is the peculiar shaped seed pod of martynia, which furnishes the basket material, for from the long elliptical pod extend two slender hooks from 20 cm. to 35 cm. long. From the back and front of these hooks are stripped short black splints, two from each hook (Fig. 46). Aside from this decorative use, martynia has another very practical one, that of supplying strength to parts of baskets receiving the greatest strain and hard usage, as it is the toughest and most durable basket material of the region. For this reason, it is used to construct the base of baskets in both tribes, the edge of the Pima ware, and many entire Papago bowls where a very strong structure is desired. Although martynia grows wild, most of the Indians seed it in their fields, since they find the cultivated plant yields pods with hooks of greater length, finer grain, and a better black. Only a few of the more shiftless Indians gather it wild. Martynia, both the cultivated and the wild, is collected in autumn when the seeds have ripened, but it must not be allowed to get frosted, for should the frost touch the pod-hooks, they will lose their good black, and become a dull grey. The pods are broken from the plant with the hands, hooked together in great bunches, wrapped in a cloth, and taken home either on the head, or in the kiaha. They are already dry when gathered, and as they are not stripped at this time, are now in condition for barter, or for storage.

When material is needed for basket-making, some of the pods are taken from the bunch and buried for a day in a damp hole under ground, with water poured over, although occasionally one finds a woman who has abandoned the old method and simply soaks her martynia pods in boiling water. When the pods are well moistened, the basket maker seats herself on the ground near the hole where the pods are soaking, and reaching for a pod (Fig. 46) splits two strips from each hook, one from the front, the other from the back. The woman here (Fig. 47) has relinquished the old position and prefers sitting upon a box instead. For stripping, the point of the hook is split into three, either with the teeth, or with the sharp basket awl against a board when the hook is stripped into three parts by holding securely between the teeth one of the outside divisions while the fingers peel away from it the remaining portion of the hook. The other outside strip is then torn off, when the outside strips are gathered together in bunches till needed (Fig. 46). When wanted for basketry, a few splints are again moistened and the white pithy wood which adheres to the inner side of these strips is scraped away with a knife, while the splint is held between the teeth and the left hand.

Nature has provided the Indian woman with her most valuable basket tools, the fingers, teeth, and feet. She supplements these natural tools

with artificial aids, the ax, or hatchet, the knife and the awl for assisting in the gathering, the preparation, and use of her basket materials. These tools she now may purchase from a neighboring city of the white man, if it is not too distant; but more often she fashions them herself, for frequently her home is in a remote village. The tool-fashioning skill of the Papago exceeds that of the Pima, especially in making the awl, which is a more shapely and carefully constructed tool than that of the Pima. In fact the Papago are neater, more thrifty, and painstaking in many ways, although in basket technic they are excelled by the Pima.

Of the tools for cutting, the largest is the ax, formerly of stone, but now a store-bought article, used for felling coarse materials such as beargrass. As a substitute for the ax in gathering lighter weight materials and cutting twigs the large butcher knife is employed; for the preparation of material, knives of all sizes, preferably the smaller are in use. These last may be old case knives, whole or broken off blades, or the knife may be something put together by the Indian herself, an old picked up blade, rubbed into shape on a stone and furnished with a handle of gum, or of two bits of wood gummed to the blade (Fig. 49a).

Along with the cutting tool there is required one for perforating holes for the passage of the binding element. The sharp pointed awl meets this need, supplied in early days by a needle or a thorn of cactus, and later by a bone or a bit of mesquite wood.[1] At present, the only materials employed to make these tools are nails or bits of old umbrella rib rubbed to a point upon a stone, while those for the handles of these points are wood, or gum. Wooden handles have the bits of umbrella rib either driven in with a stone, or burned in after heating if the wood is hard, when the steel may be run into either end of the handle. The simplest method is to sharpen the steel and drive the point up through the handle from its lower end, but this method is not practised as frequently as that of pushing in the steel from above, either sharpened or unsharpened. The unsharpened steels, when run in from above, are driven into the handle and the remaining exposed steel then sharpened; the sharpened steels may have their points driven in, or burned in, before the remaining exposed portion is sharpened. When the steel point is completed the handle is shaped by whittling and smoothing with a knife. Papago handles are of mesquite wood, or old broom handles; Pima are of willow, cottonwood, mesquite wood, mesquite root, or some old tool handle. The material for gum handles is the secretion of a tiny insect (*Carteria larreae*), found upon the greasewood twigs. This twig bearing the secretion is broken off, held over the fire until the gum is softened, and

[1] Isaac T. Whittemore, *ibid.*, 52; Frank Russell, *ibid.*, 135.

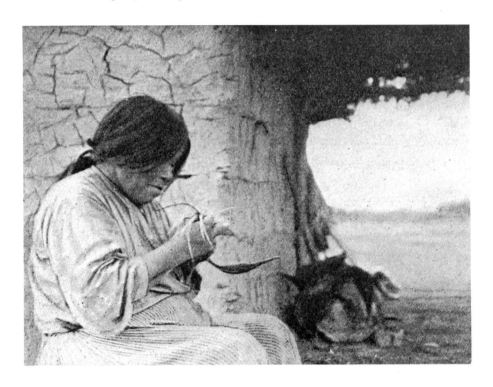

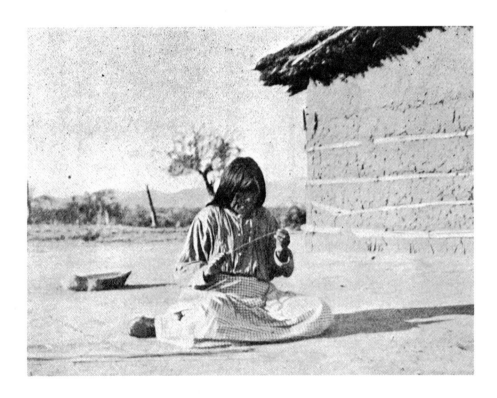

Fig. 47. Splitting the Martynia.
Fig. 48. Splitting Beargrass for the Foundation Element.

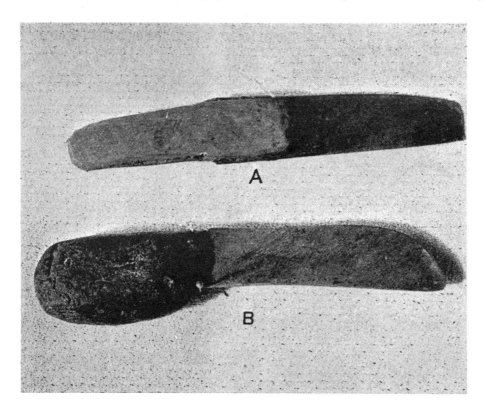

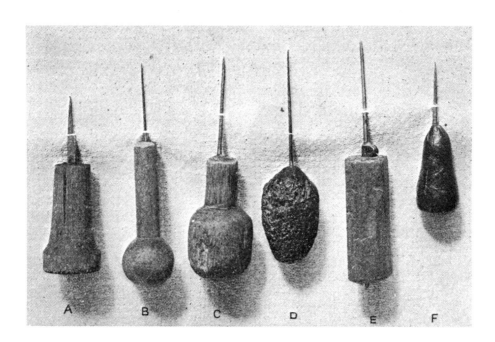

Fig. 49 (50.1–5161, 5162, 5218, 5221, 5155, 5216, 5156, 5157). Basketry Tools, Papago.

then shaped with the fingers about the end of the steel, when, with cooling, the gum becomes hard like wood (Fig. 49b). Another gum less frequently used is creosote (*Covillea tridentata*, or *Larrea Mexicano*).

At almost any hour of the day one will find some Papago or Pima woman before the door of her hut at basket-making. Like other duties, this is a part of the regular work of this busy woman, for she is expected not only to tend to the regular household affairs, but to bring all the fuel and water and in olden days to help in the fields, and for these she has need of utensils for pottery and basketry and so must provide herself with them. Most basket makers learn the art from their mothers when young girls, but now and then one is found who has acquired the craft when a grown woman. Judging from the present results of makers of coiled ware it takes a life-time to perfect the art, since the old women are now making the best baskets, although it is possible that this is due to the influx of civilization which tempts the younger generation to abandon the old arts for the customs of the white man.

When making coiled baskets the Indian woman sits tailor fashion on the ground upon a square of canvas (Fig. 53). If the day is hot she selects some comfortable spot, usually on the shady side of the hut; if cool, she sits in the sun; but when cold weather sets in she is driven within doors, except during the warm midday. • Within she plies her art just inside the door, her only means of light as few huts have windows, but when very cold days come she may be forced to stop basket work entirely for then the door is closed. Then she squats beside the low fireplace with its fire of mesquite wood, or before a pan of hot coals in the middle of the room, for these women wear very little clothing, perhaps nothing but a cotton dress even in the coldest weather. Placed beside the basket maker, to assist in the work, are the dish of water for moistening and soaking the materials; the basket tools, a knife and an awl (Fig. 49); as well as the materials, the dry split beargrass, or cat-tail, lying loosely on the ground for the foundation, and the willow, cottonwood, or martynia splints (Figs. 45–46) soaking in the dish, or the yucca wrapped in a dampened cloth for the binding element.

Coiling is begun by most peoples with a bit of the foundation material bunched together, bound, and then coiled in concentric circles. Few tribes deviate from this method, but the Pima and Papago make a very different beginning, a plaited center, most commonly constructed with six strips of binding material arranged in two groups of three strips each, and during the making either laid on the knee or held in the left hand during the first few moves. The two groups are placed so as to cross each other at right angles near their center, as seen in Fig. 50ᵃ, which is the back of the center. One set of ends of the lower group is then bent up and over the front so as

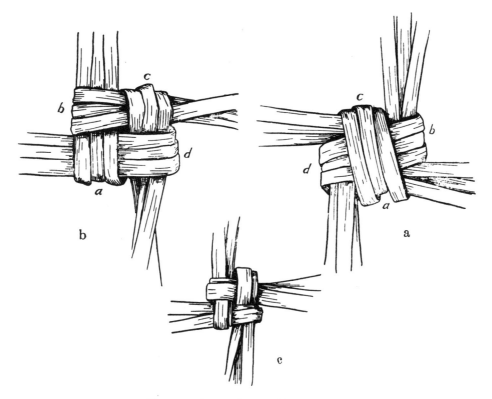

Fig. 50. Beginning of Close Coiling.

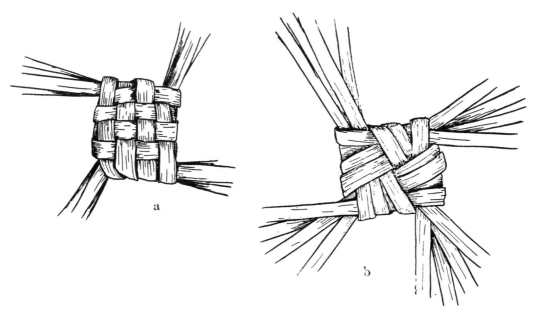

Fig. 51 (50.1–5124a). A Second Close Coil Beginning, Papago.

to pass over its own strips, but deviating slightly toward the left (Fig. 50a ᵃ). The next group of ends, the left, is similarly bent, crossing it at right angles over the first group of ends (Fig. 50b ᵇ). The third group is similarly bent, crossing the second ends (Fig. 50c ᵇ), and finally the last group is bent across the third group, but it must be slipped under the first group to hold securely (Fig. 50d ᵇ). The ends are now pulled tightly in place that the center may show four small squares within a large one (Fig. 50 ᵇ). At this point the center is turned over, so that the four small squares will be below, and the

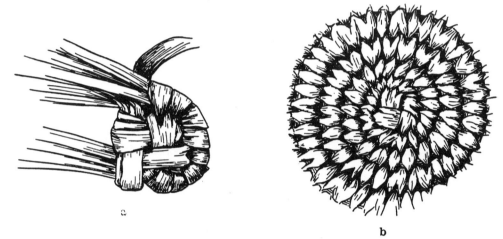

b

Fig. 52 (50.1–5125, 5196). *a*, Coiling Begun; *b*, Further Coiling, Papago.

first diagonal crossing of the two groups will be above (Fig. 50 ᵃ). Each set of ends must now duplicate the moves before made on the front, that is, each group is bent so as to cross the center in regular succession to form the four squares, giving a second face like Fig. 50 ᵇ, or a double faced center as in Fig. 50 ᶜ.

Another center is occasionally used, although it is not so common as the one just described. Its eight strips are arranged in two groups of four elements each, which cross at right angles, and plait over and under one another in regular checked plaiting (Fig. 51a). The four ends of one side are then bent across the top as in the first group of ends described in the previous center (Fig. 50). In like manner, the ends of each side are taken in successive rotation and bent across the previous set as in the groups of ends in the previous center (Fig. 50–51).

Either of these centers is now ready for regular coiling to begin, before which, however, all the strip ends must again be wet to avoid breaking when bent. A group of ends is then turned to the left to act as a foundation and bound down to the center by an extra binding element which is added here. It passes around the group of ends and into the edge of the center through a

hole already pierced by the woman's awl (Figs. 54, 56), and so continues until the second group of ends is reached, when this group is turned to the left and bound down as the last group (Fig. 52a). This is continued until the point is reached where the binding element was first introduced, when splints of the foundation element, beargrass or cat-tail, are added to the splints already acting as a foundation and all are caught down as before by the binding element, which enters the edge of the first row of coiling. The binder enters the previous coil between the segments of the spiral, or stitches as they are sometimes called, and does not interlock with them (Fig. 52b). Pima basket makers are very exact in this placing of the binding element, giving their baskets a more ridged surface, while the Papago are less particular, producing a rougher, less even surface.

So coiling continues until the base has reached the desired size, when the walls are begun by a change in the position of the foundation coil in process. This is not placed, as before, on the top of the last round of coiling, but is bound to its side and at such an angle as is proposed for the erected wall. It is this shifting of the position of the foundation coil which makes possible the shaping process, allowing the walls by incurving, or outcurving, to alter their outline to suit the fancy of the maker. Figs. 53–58 show quite clearly the process of coiling: the woman's position on the ground in front of her hut (Fig. 53); the puncturing of the hole by the pointed awl (Fig. 54); the biting sharp the end of the binder so that it may easily enter the hole when the awl is lifted (Fig. 55); the pushing of the binder through the hole (Fig. 56); the pulling it tight and the holding of the awl when not in use (Fig. 57); and the adding new splints to the foundation (Fig. 58). New binding splints are joined by pushing the new splint through the last binding hole and covering the last segment of the old splint before entering the newly punctured hole. Figs. 53–57 show a Papago basket maker at work on the small beginning of a coiled basket, and Fig. 58 represents a Pima woman with an almost completed bowl adding fresh foundation material.

Grim necessity no doubt had much to do with the development of shape, size, and technic in basketry, but other causes are responsible for the presence of design and the finer qualities of craftsmanship, for it was freedom from the strain of necessity which nurtured into being the fine arts. Leisure and abundance of time, is the staunch friend of the Indian in working out basketry decoration, time to play with her units of design, to arrange them into patterns to best fit them to the purpose in hand. So in the designs on the foundation coil of these tribes, which in abundance and elaborateness of pattern hold first place among their basket technics, there are interesting examples of invention and adaptation. The design of foundation coil is less influenced by technic than other kinds of basketry, especially when

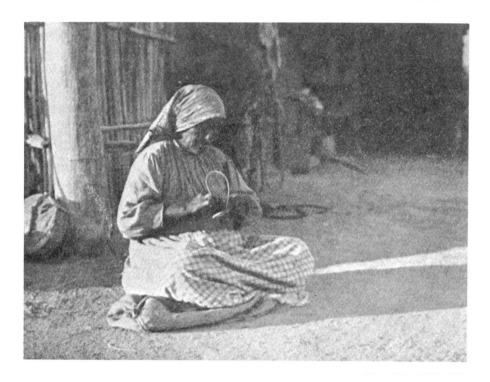

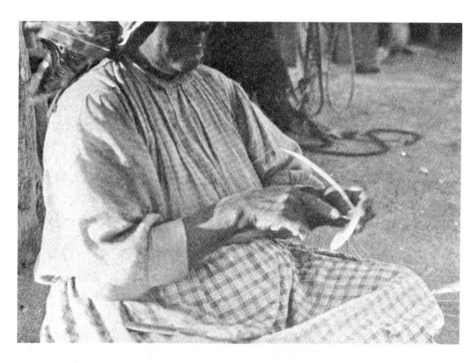

Fig. 53. Papago Basket Maker, showing general position.
Fig. 54. Papago Basket Maker, showing use of the awl.

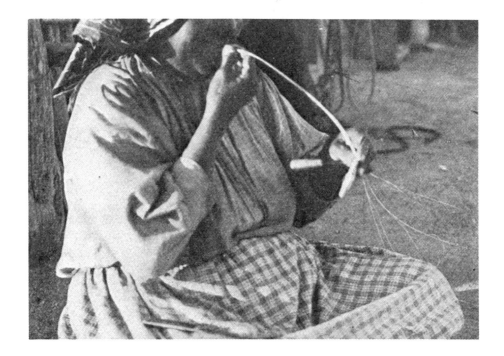

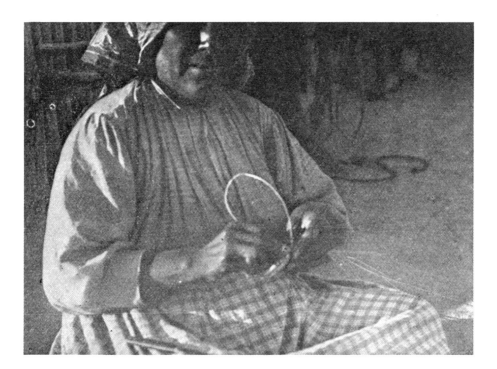

Fig. 55. Papago Basket Maker biting Sharp the Binding Element.
 Fig. 56. Papago Basket Maker inserting the Binding Element in the Hole made by the
Awl.

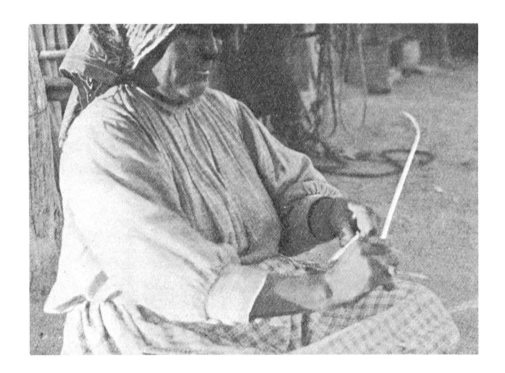

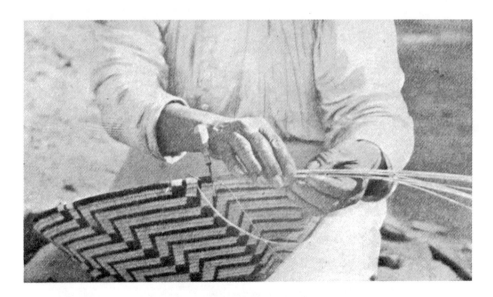

Fig. 57. Papago Basket Maker tightening the Binding Element.
Fig. 58. Pima Basket Maker adding Foundation Material.

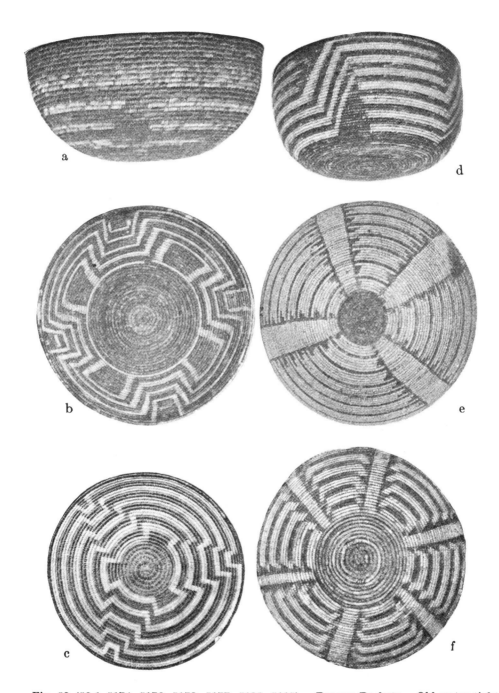

Fig. 59 (50.1–5174, 5176, 5179, 5177, 5182, 5115). Papago Baskets. Old water-tight baskets of exceptional interest.

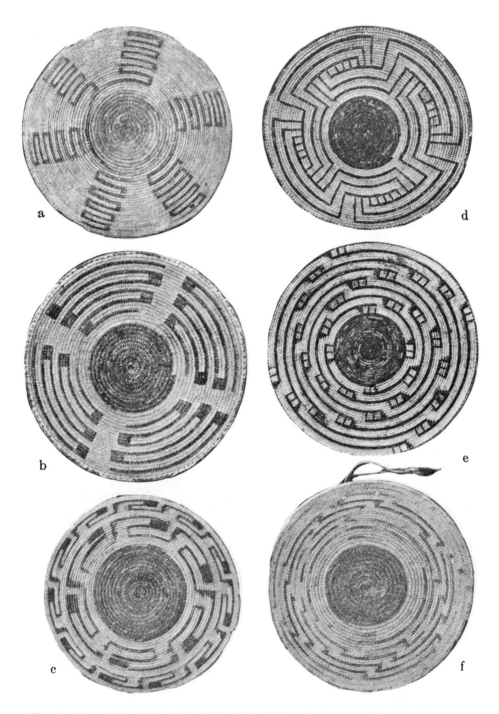

Fig. 60 (50.1–5112, 5181, 5308, 4205, 5280, 5187). Papago and Pima Baskets: *a, b, f,* Papago; *c, d, e,* Pima. *f* is specially interesting as the food tray of the medicineman of Santa Rosa.

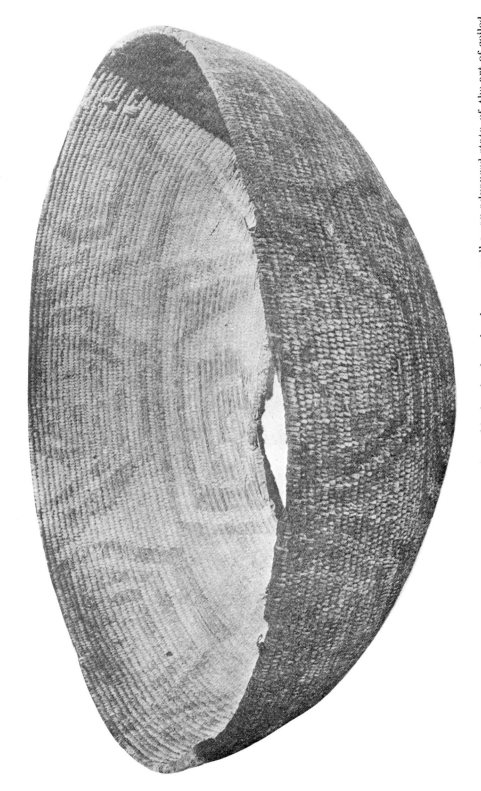

Fig. 61 (50.1–5172). Old Papago Bowl, five generations old, showing long hard use, as well as an advanced state of the art of coiled basketry when it was made.

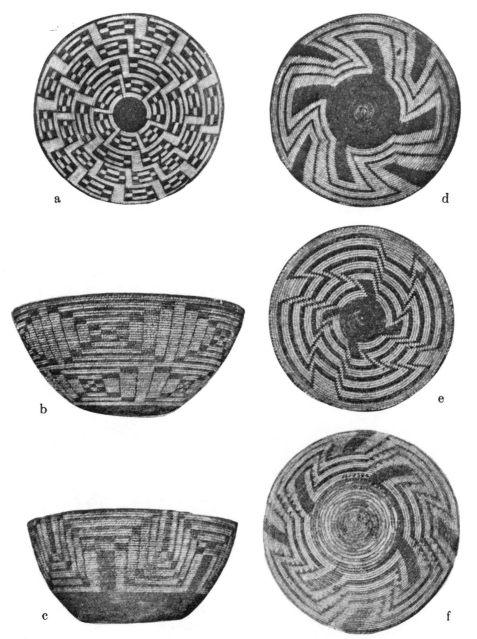

Fig. 62 (50.1–4769, 4770, 4786, 5306, 5185, 5282). Pima and Papago Baskets. *a, d, e, f,*
Pima; *b, c,* **Papago.**

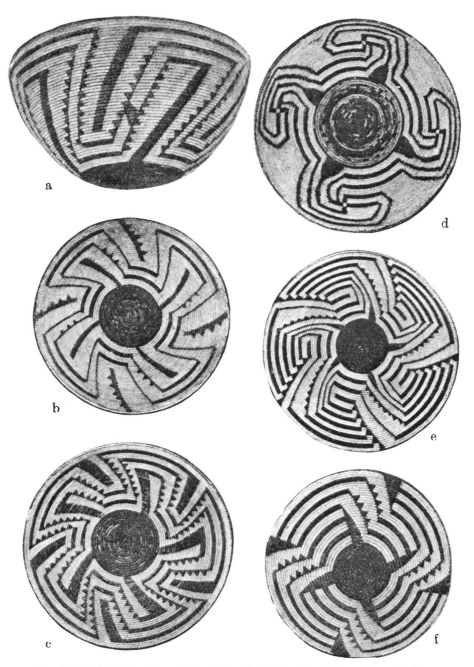

Fig. 63 (50.1–4109, 4724, 5282, 5175, 50–2748, 50.1–5264). Pima Baskets.

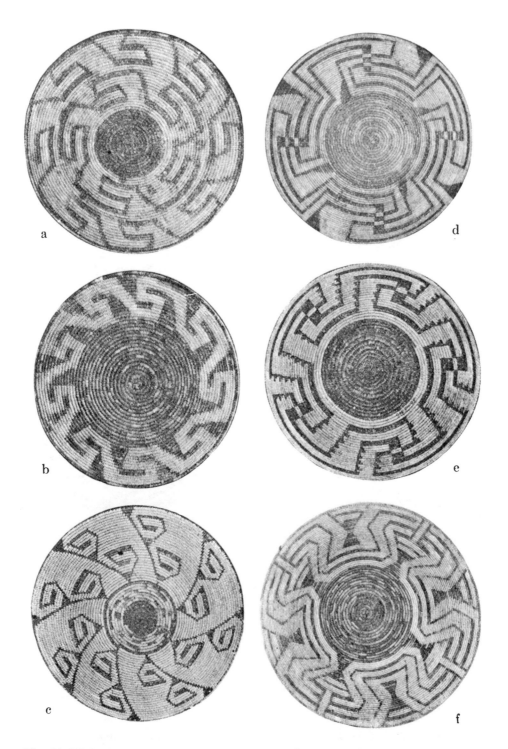

Fig. 64 (50.1–4045, 4106, 4207, 5254, 5310, 5265). Papago and Pima Baskets. *a, b,* Papago; *c, d, e, f,* Pima.

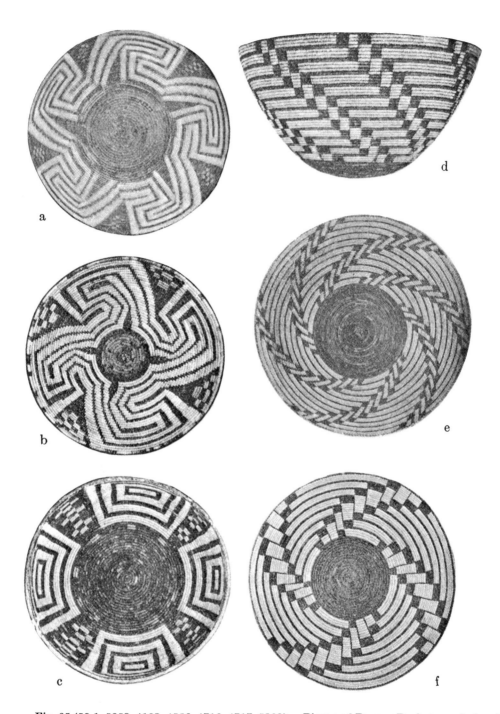

Fig. 65 (50.1–5253, 4103, 4566, 4716, 4717, 5309). Pima and Papago Baskets: *a, b, d, e, f,* Pima; *c,* Papago.

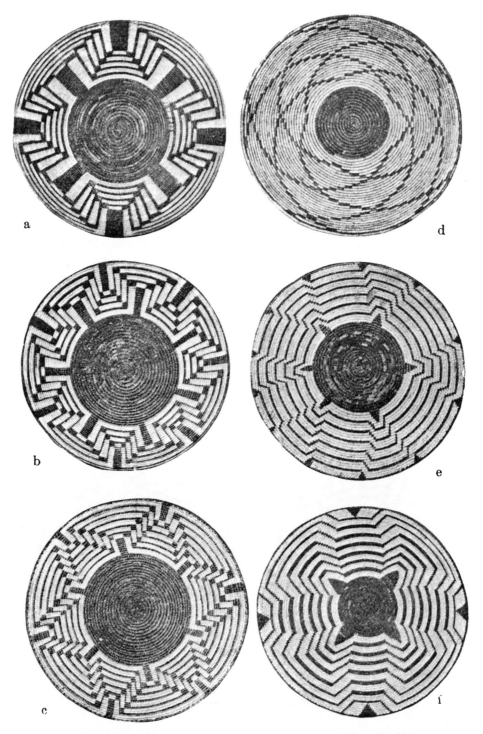

Fig. 66 (50.1–5305, 4730, 5329, 5183, 5245, 5256). Pima Baskets.

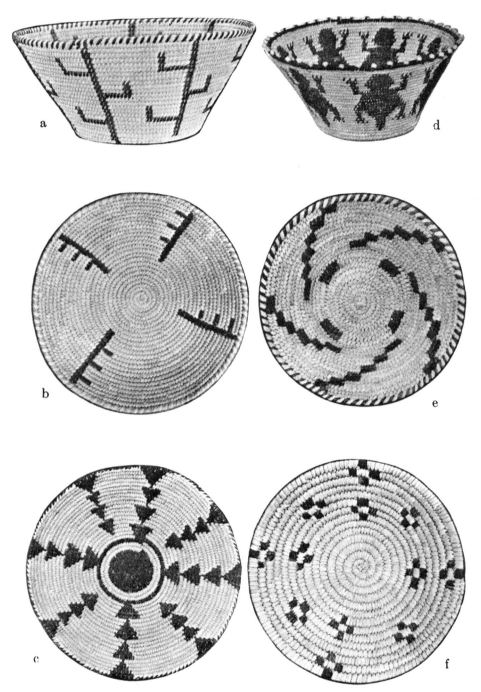

Fig. 67 (50.1–4190, 4089, 5197, 4191, 4088, 4065). Modern Papago Baskets.

the binding splints are narrow and the foundation coil slender. The greatest limitation comes from the width of the foundation element, whose breadth is troublesome in arranging curves, which must be built in series of steps.

Design here is in black and light straw color; more usually a black pattern on a light ground, as with the Pima, and at times, the Papago; or a light pattern on a black ground as only with the Papago. The decoration is in line design, with at times accented portions, producing a fine dark and light effect as seen in the strong bold decoration of the Papago. Constant trading and interchange between the two tribes has mingled designs, making the decision difficult to which tribe a design belongs, for often designs from both tribes are found on the same basket. However, the

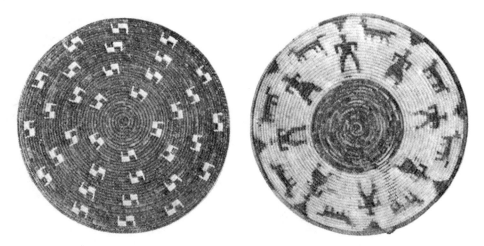

Fig. 68 (50.1–5303, 5113). Modern Papago Baskets.

general plan for Papago and Pima baskets is the same, a base of solid black, the entire wall acting as the field of design which is entirely filled with pattern.

As to the design motives, there are several theories, both as to the origin and design significance. Dr. Lumholtz states in his narrative of the Papago:—

That significance of decorative design is almost entirely forgotten. There is only one woman at the present time who is able to do first-class basket work and she cannot tell what the design means.[1]

Dr. Russell on his visit to the Pima records:—

When questioned as to the meaning of the elements of these patterns, the basket-makers invariably replied: 'I do not know; the old women make them this way. They copied the patterns long ago from the Hohokam pottery.' [2]

[1] Lumholtz, Carl. "New trails in Mexico," 353.
[2] Russell, Frank. *Ibid.*, 135.

The information given by the older Papago and Pima women in 1910–1911 was much the same as the last, " I do not know, the old women make them so." None of these, however, reported their being copied from the old pottery, quite possibly the women who so reported in 1901–1902 were gone. Besides, the copying has yet to be proven by a more intensive study of collections of prehistoric pottery from the region in relation to the basketry pattern. It may be found that Papago design motives are indigenous — survivals of an older prehistoric basketry design. Their strong direct simplicity suggests this, but a sufficiently comprehensive study has not as yet been made to substantiate this theory. It is hoped that the Quijotoa, Comobabi, and Baboquivari villages will yield up to some future investigator something of value on this lore.

Although the older women furnished the above report, some of the

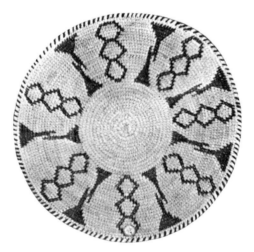

Fig. 69 (50.1–5194). Modern Papago Basket.

younger and more commercially inclined gave names to the more common designs. To all appearances these women had responded to the questions of travelers, who for years have been visiting here, for the meanings of these patterns, and were reading into them modern names, such as recorded in the lists below.

Dr. Lumholtz lists the following Papago design names:—

Dog tracks, Fig. 65a, b, c.

Saguara, Fig. 67ab,

Turtle, Fig. 62a.

Martynia, Fig. 65ab,

Juice-falling-from-saguara-fruit, Fig. 60a.

Dr. Russell's list of Pima design names is as follows:—

Atcuta — black center of all baskets.

Kakiopins — "crossed lines."

Kamketcit — "turtle," Fig. 62a, b.

Mavspitchita — "locked together."

Moumvitcka — "triangular," "terrace," Fig. 63.

Opumusult — "parallel lines doubling upon themselves," Fig. 60d, e.

Pan ika kita — "coyote tracks," Fig. 65a, b, c.

Sa-si — "figured."

Sihitalduwutcim — "whorled," "spiral," Figs. 65d, c, f, 64 c.

Sisitcutcufik — "very much figured," Fig. 66e, f.

Stoa — "white."

Supeputcim kakaitoa — "striped with black and white."

Tasita — "set" or swastika.

Tcoho-otcilt — "crooked lines" or fret, Fig. 60c.

To these lists must be added a Pima name for a more recent design, not present fifty years ago, the "squash blossom"—Fig. 66a, b, c, and one given by the Papago to the design Dr. Lumholtz reports as "juice falling from saguara fruit," that of "deer tracks in woods," of which Fig. 60a, shows a simple rendering of a design with a number of more elaborate forms produced by folding and doubling the long continuous line. The design "dog tracks" is the same as "coyote tracks," and the design "turtle" is quite similar, but composed of more rectangular spottings, and quite frequently enclosed in a square, or covers an entire basket. One hears so frequently the design names, "coyote tracks," "turtle," "martynia," "crooked lines," "terrace," "squash blossom" that one is forced to believe that these designs have been so designated for many years.

An interesting transition stage is at present in process in the art of these people, both as to shape and design, owing to the influence of civilization: new shapes suited to the life of civilized man, and new designs due to his call for a meaning to the patterns. In response to this influence the Pima have greatly altered the shape of their baskets, so that curio shops are filled with the novel forms, waste-paper basket shapes, and large olla jars, beside a variety of smaller baskets, upon which are worked their old motives. These are not exact copies, but parts chosen from the old patterns and repeated in other ways, and often in a careless manner. To these are added, through the encouragement of traders, two other motives, the human form and that of animals. The Papago have introduced into their modern baskets, new material, new shapes, as well as new designs. But instead of arranging bits of their old patterns in a different way as did the Pima, they have for the last ten or more years been inventing fresh motives, based upon objects in their surroundings. Desert plant life has furnished many motives; the giant saguara is represented by a simple shaft (Fig. 69), or

branched on one side (Fig. 67b) or branched on both sides (Fig. 67a); other cacti by a symmetrically balanced figure with the branches turning up, and others with branches turning down; a general plant form with a central stem and two balanced triangular shapes for leaves; yucca spines by a quadrilateral figure with a fringe of vertical points. Animal life is portrayed in designs of men and women (Fig. 68b); horses, dogs (Fig. 68b), deer, deer trail, coyote tracks (Fig. 67f), rat roads and horned toad (Fig. 67d); the heavens by three stars (Fig. 69); the fields by a design showing ground fenced in; and various other representations show roads, benches, stairs, steps, lightning (Fig. 67e), monuments, kiaha frame, smoke, fire, and arrow points (Fig. 67c). One Pima tray was collected from an old woman who was inventing her designs. Fig. 68a shows this tray with the design "night and stars." This example is a contrast in technic and careful planning of design to the cruder Papago design, whose new type of pattern has not as yet reached a developed stage.

Further consideration of pattern in connection with the units of design, their treatment and arrangement, together with a description of the figures illustrating Papago and Pima coiled basketry will be found in another section of this paper (p. 255).

LACE COILING.

Decidedly unlike foundation coil with its two elements is lace coil, an openwork texture constructed of one element which corresponds in a way to the binder of the last technic. Crude coil had only one element but it served the two functions, a groundwork and a uniter. Here the foundation is entirely lacking and only the binder is present, but it unites by such a method as to form a surface without a groundwork. In some regions the technic is of stiff materials, when Mason styles it "cyclodial," in others, it is of soft fiber, strips of palm leaf, thong, or sinew, when it is named by the same author "buttonhole coil," and "coil without foundation." Technically, these three are identical, since their only difference is one of name; and the last term is the best since it more tersely describes the method of putting together. Another shorter and equally appropriate name is the one used here, lace coil, since its technic is that of point lace. Hence, lace coiling is a basketry technic of much significance, not only in its usefulness as a maker of openwork bags, carrying frames, garments, and headgear, both utilitarian and ceremonial, but also in its relation to the technic of lace making, for basketry lace coil is the crude beginning of modern point lace. It is of moment that this open texture of native string, from peoples of lower culture, has been carried into civilized life in needle-point lace,

done in thread by the peasants of Europe. At this point basketry and lacework meet, for the one element in basketry lace coil and that of the simplest point lace, are manipulated with the same spiral movement (Figs. 70–71).

The one flexible element in lace coil, like the binder of foundation coil,

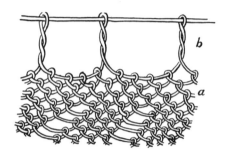

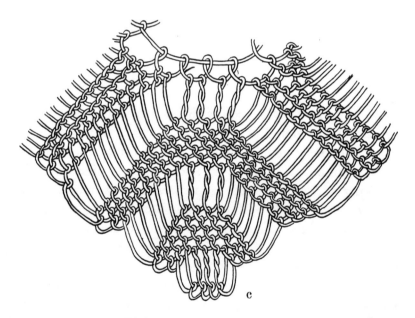

Fig. 70 (50.1–5150, 5237). *a*, Plain Lace Coil; *b*, Twisted Lace Coil; *c*, Elaborate Lace Coil.

advances about the bag, basket, garment, or cap in a large continuous spiral; and likewise while following this larger movement, it unites the adjacent rounds of the technic by looping itself in a small secondary spiral into the previous round of the technic. In this looping, the smaller spiral may move in a plain coil, or it may twist, interlace, or knot while so doing, giving rise to different types of lace coiling. The Pima and Papago practise but two

of these: plain lace coil (Fig. 70a), and twisted lace coil (Fig. 70b, center). This last varies slightly from the simple looping described above, by a wrapping about the upright portion of each loop, before passing to the next.

Although the one element in lace coil is fundamentally so like the binding element of foundation coil, the two technics as found in this region, differ both in the direction of the movement and in the method of building. The direction of the movement in lace coil is towards the right, or clockwise, in what seems to be the most natural direction with right-handed people, for the manipulation of one element with the right hand would more easily

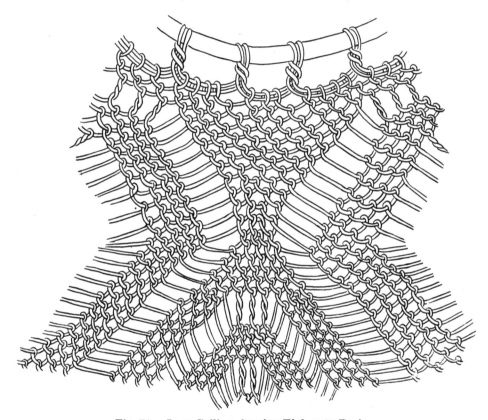

Fig. 71. Lace Coiling showing Elaborate Design.

progress toward the right; but in foundation coil the movement is towards the left, or counter-clockwise. Foundation coil is built up from below, each segment of the spiral rising above the last; lace coil is usually suspended during the making and worked downward, each segment of the spiral descending as the work progresses (Figs. 70–71). Another difference in technic is the interlocking of adjoining spirals in lace coil and its absence in the binder of the foundation coil.

The distribution of lace coiling is a wide one as it is met with in the tropi-

cal and semi-tropical regions of North and South America, Africa, and many of the Pacific Islands where soft fiber plants, and raphia palms grow. However, it is not limited to the habitat of these plants, but has a scattered distribution far to the north and south, not only where fibers of various kinds are found, but where animals furnish thong and sinew for its construction. In the hot lands of Africa, the technic most commonly fashions caps, fetishes, masks, armour suits, and bags; in the warm countries of America and the Pacific Islands, soft bags and carrying frames; in colder countries, game rings, travois, saddle bags, game bags, ceremonial headdresses, and even blankets. Still, in the wide distribution of this technic, nowhere is it found in the beautiful designs which appear on the lace carrying frames and bags of the Indians of southern Arizona and northern Mexico.

In olden days the women of this region were the bearers of burdens, either in the kiaha on the back; or in the basket, the bundle, or the olla upon the head. To assist in carrying their loads on the back, they constructed the conical shaped kiaha, or carrying frame, of lace coiling (Figs. 75–81). One early writer describes it as a "singular piece of framework made of poles with netting for carrying on the back and seen in every wigwam to answer the purpose of wheelbarrow."[1] Since the advent of the horse among the Papago and Pima, the kiaha is not in such constant use as formerly. It was almost indispensable as a carrier for all manner of things and there was hardly a home without one. In its light but strong frame were carried fuel, food, and the materials for various manufactures. One day it might be piled with firewood, the desert mesquite; another, with beans, squashes, and grains; and still a third with grasses for baskets, reed for mattings, and fiber for kiahas; while on top of any of these loads might be seen an infant strapped in its basket cradle. Today, the kiaha is not an uncommon object in the out-of-the-way villages, where one can catch frequent glimpses of burden bearers bringing home their kiahas loaded with firewood, grain, beans, and other produce; or can observe the empty carrier leaning against the house wall, or propped by a post of the shed-arbor, or even tossed upon the roof itself.

Papago material for lace coiling is furnished by the great leaves of the agave (*Agave sp.*), and that formerly used by the Pima was the maguey, a species of agave. These fleshy, spiny-leafed plants grow in the higher hills, and are in perfect condition for yielding fiber in the rainy season, so it is obtained then. The best leaves are the soft inner ones next to the central stem, which are gotten with much difficulty, for they must be knocked off with a heavy stick. The leaves are done into a bundle and carried home

[1] Bartlett, "Personal Narrative," II, 236.

on the head, or are packed into the kiaha and carried on the back. The Papago and Pima construct only one article of lace coiling, their kiaha, or carrying frame. As it was in constant use before the advent of the horse, much fiber was needed for its manufacture. The fiber gatherers then went to the hills in parties, instead of singly as now, since the demand for fiber has dwindled with the passing of the kiaha, and individual women can secure the scant supply now needed.

Formerly, the fiber was prepared on the hills before returning, since fiber was lighter to carry home than the heavy leaves. For the preparation of the fiber, fires were built in pits, the hot coals drawn out, and the thick leaves laid in their place, to roast over night. The skin and pulp from the softened leaves were then scraped off with deer scapulas, leaving the free fiber, which needed only to be washed and dried. The present-day process of preparation, substitutes for the pit fire on the hill, the open fire within the hut. Over this the leaves are put to boil, or laid in the hot ashes to bake and when quite soft they are scraped to clear the fiber, which is then washed and bleached two or three days in the sun (Fig. 72b).

The spinning of the fiber in early days was also a social event, when a number of women assembled for that purpose. Now neighbors may gather, but seldom is there more than one woman of the group who is spinning. This she accomplishes not with the spindle, but on the bare leg, formerly on the bare thigh, but now on the leg just below the knee, for modern clothing makes the first an impossibility. The spinner sits on the ground with her left leg under her, and her right so bent as to be of service during the spinning. On this she places two strands of fiber with her left hand, and with the palm of the right, rolls the two simultaneously away from her, thus giving them a hard twist. These two tightly twisted strands are released by slightly raising the hand, and then bringing it lightly toward her, thus uniting and twisting the two strands into a two-ply cord, by rolling in an opposite direction (Fig. 72a). Spinning between the palms, or on some part of the leg, is widespread among peoples of lower culture, especially for the twisting of vegetable fibers.

The tools for converting fiber cord into this widely distributed technic, show a great diversity in the many localities. At times only natural tools are employed, as the fingers, at others a cylindrical mesh stick or a needle, the first being especially serviceable when an open texture is in process of construction, and the last when a close one. Needles range from those furnished by the animal kingdom, as a pierced fish bone, a hollow flange of the front limbs of the pteropos, or some other bone, as in New Guinea and other Pacific Islands,[1] to those furnished by the vegetable kingdom, as

[1] G. A. J. Vander Sande, "Nova Guinea," III, 184.

the Mexican bamboo needle with pierced eye, or the long splinter palm midrib needle from tropical Africa, with one end sharpened for the point, and the eye end beaten to a fiber, so that it may be attached to the cord it is to carry by being twisted with it.

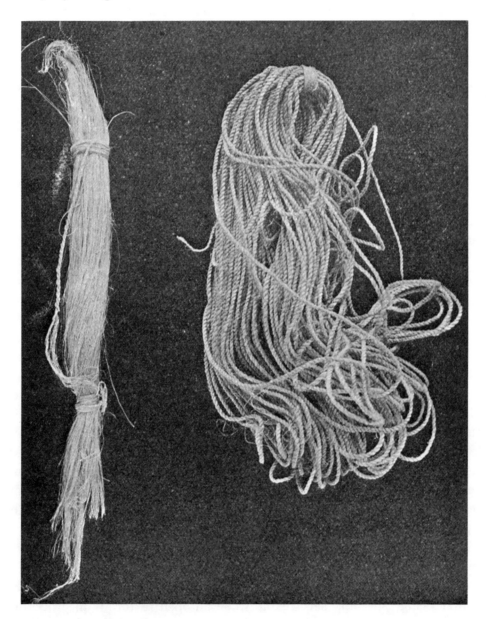

Fig. 72 (50.1–5293, 5148). Agave Cord and Fiber.

The Pima and Papago avail themselves of a number of means for pushing the cord through the loopings. The fingers only may perform the work, or a sharpened stick, or as has been reported a thorn needle formerly served

this purpose, although no information at this late day corroborated this report. Years ago white men brought to them a new material for needle-making, the umbrella with its steel frame. So a bit of old umbrella rib now furnishes material for most of the needles for lace coiling. A bit of the rib with one of the little eyelets attached which earlier fastened the umbrella cover to its frame is first broken off, one end is then rubbed down, and the other has the eyelet carefully preserved for the eye of the needle (Fig. 73a). More recently, the Indians living nearest the cities have procured for lace coiling the store-bought upholsterer's needle (Fig. 73b). The mesh stick, a short cylindrical, or flat rod, finds employment in some localities where openwork lace coiling is made, since over it the loops are thrown while

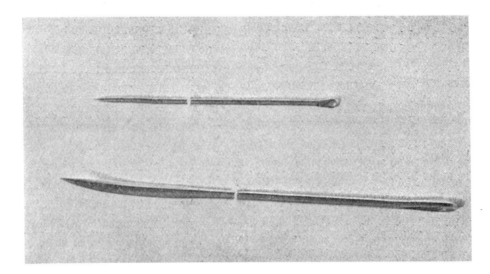

Fig. 73 (50.1–5239, 5240). Needles used for Lace Coiling, Papago. *a*, made from an umbrella rib; *b*, a store-bought needle.

making, to ensure a uniformity of mesh when the lace coil is of openwork texture. None of these were found among the Papago, or Pima, since here the closeness of the mesh does not necessitate, or even permit, its use.

In some regions an artificial support is employed for suspending the work during its fabrication: a post, or a twig, if the shape is circular; a lathe-like stick, or a rod, if it is rectangular. The Pima and Papago use no such support for the beginning rounds of the kiaha although later in the process they throw the beginning string over the big toe, and this acts as a stay for holding the work, thus freeing both hands for the management of the cord loopings. Seated on the ground in tailor fashion the Indian woman first makes a small fiber ring about seven centimeters in diameter and holding this in her left hand she casts upon it the first row of loops (Figs. 70, 74). She loops

a second row into the first row and a third into the second and so continues until a few inches of the work are completed (Fig. 74) when extending one foot she slips over the big toe the beginning ring and in this position continues the looping, or lace coiling, until the kiaha is completed. Interesting as is the simple looped string work, it cannot compare with the elaborate variations of the technic which occur on many of the kiahas after the first few inches of plain looping are passed, for the maker may vary the method of looping by catching the coil into the previous round of the work in two different ways, thus producing two units of design (Fig. 70). Again she may vary the groupings of the design unit, setting some close together, others farther apart, for great latitude in variation is possible in the rhythmic arrangement of the design unit (Figs. 70–71, 74–79).

That this feeling for rhythm is strong in the Indian woman is shown in the patterns. Intuitively, she makes use of this and other principles of design: rhythm, variation, subordination, principles of art which are taught with much labor to students in the schools of civilized man; but this Indian never spent a day of her life in an art school. Originally, in all probability, the variations evolved as the maker played with her string of fiber, but in more recent days a design was copied from that made by the mother. Today, few women make only the one pattern their mothers taught them when girls. This is too monotonous, they like greater variety, and so construct a number of patterns, but always copies of some old design. The faculty for invention together with a native appreciation of design must have strongly influenced kiaha art, while possibly a third factor may have been a force in shaping it, namely, the intense holding of these people to certain ceremonial ideas and religious beliefs, for who can tell what superstitions have been looped into the wonderful point lace kiaha. Probably no one will ever know the meaning of these designs, since if they have significance, it has long been lost to the tribes through the great influx of civilization.

When the point lace cover is completed, the edge is bound by fiber cord to a twig of cat's claw (*Acacia Greggii*) bent into circular shape for the rim (Figs. 75–81). The cone of lace with its wooden rim is next fitted to a spider-like frame of giant cactus rib (*Cereus giganteus*), whose four poles are secured to the lace body by a cord of human hair, or of horsehair, which also ties together the lower ends of the poles at the point of crossing just below the lace cone (Figs. 75–81). A back mat of plaiting (see p. 158), with its soft back pad of shredded bark slipped in where the crossed poles rest on the shoulders, and a headband of plaiting (see p. 164) must also be firmly attached to the kiaha. There remains but one other thing to complete one of the lightest and yet strongest of carry-alls, a carrying frame so well fitted

to the heavy loads these Indian women must carry. This is the intensifying
of the lace design with bright-colored paint of indigo blue and red earth,
for any design may be painted, and from the applied color become so changed
as to result in a number of variations. Paint as well as decorative fringes
of skin are also added to the long front frame poles of young girl's kiahas.

During the loading of the kiaha it stands on the ground resting upon the
two front frame poles which protrude a foot below the lace body, steadied
by a third pole, the kiaha stick, or helping stick as it is sometimes called
(Figs. 80–81). It is a long slender rod with a forked end provided for this
purpose, that it may act as a prop since its pronged end catches under the
kiaha rim and the other rests on the ground. When the kiaha is loaded,
the woman gets down on the ground, and shoving her back under the front
of the kiaha, slips the carrying band over the crown of her head (Fig. 80a).
If the load is a heavy one she will grasp the kiaha rim with one hand as she
helps herself to her feet with the kiaha stick in the other hand. Should the
load be light, it is not necessary to steady the kiaha, so as she rises, she
grasps the kiaha stick in both hands (Fig. 81b). When the load is well
balanced upon the head and shoulders, the kiaha stick is either thrust into
the front of the load, or used as a staff while walking. When carrying the
kiaha the Pima wear the hair parted with it hanging loosely to the front
over each shoulder (Fig. 81), but as the Papago dress the hair in two braids
a braid replaces the loose hair on either shoulder.

In abundance and variety of pattern, lace coil holds second place to
foundation coil, the technic which constructs numberless trays and bowls;
kiahas are few in comparison, one for many of the coiled wares, but these
few exhibit an elaboration and a delicacy of pattern which is unsurpassed.
The designs on the figures here shown are representative of patterns now in
use, of which the greatest favorites are Figs. 76ab, 79ab, and 78a. The
larger number of kiahas in use before the introduction of the horse and later
the wagon, which has lessened the need for this transportation vehicle, may
have furnished other designs, since the technic admits of many variations,
as is seen on the rectangular bag shapes from farther south in Mexico and
South America. These present other varieties in design but not more
elaborate ones, since the lace coil patterns on the kiahas of this region are
far in advance of those from other areas.

The design must be carefully planned from the very beginning, as made
clear in Figs. 74 and 70–71, for it is built of the two varieties of lace coil, and
in such a manner that plain lace coil forms a close texture and the twisted
variety an open one, and the two interspersed form bands and figures at will.
Counting enters largely into this complicated pattern making, which begins
with some rhythmic arrangement and unfolds and grows as the lace coiling

continues, widening from time to time with the enlarging form of the cone-shaped cover. It is the entire surface of the lace cover which serves as an unbroken field of design, over which the pattern is spread in two types, the encircling and the radiating, the last of which is the most common and probably in earlier times, the customary one.

Usually, the radiating pattern is divided into four parts, as if planning for the four poles of the frame, and on some kiahas the designs are nicely fitted to the poles but on others more poorly. At times the four divisions are strongly indicated, as in Figs. 75, 76, and 78a, and again less noticeably, as in Figs. 79 and 78b. These divisions are generally marked by a shaft extending from apex to rim, Figs. 78a, b; or part way from the rim, Figs. 76, 77a, and 79; or a short distance from the apex, Fig. 75b. Frequently the shaft tapers from a wider base, especially if rising from the apex of the kiaha (Figs. 75b, 78), but if dropped from the rim it frequently grows to spear shape (Figs. 76, 77a, 79), while again, but less seldom, it may hold to uniform width throughout (Fig. 77b). The design between the shafts may be an entirely distinct unit in itself (Figs. 75a, 76, 77, 78), or the design of quarter sections may be merged into one pattern (Figs. 79, 75b). If the first, the enclosed designs may be formed by horizontal bands (Fig. 77b), oblique bands (Fig. 78a), rows of triangles (Fig. 78b), balanced figures (Figs. 75, 76, 77); or the pattern may consist of meandering frets (Fig. 79) (see later description of kiahas, p. 234).

The addition of color to these designs is the finishing touch, as it intensifies certain parts and also allows a degree of diversification, since any design admits of a few variations through the application of color. When the lace coiled covering is completed and stretched on its frame the red or blue mineral paint is applied to the openwork bands only. An interesting experience long to be remembered was the gathering of three or four Indian women around an old uncolored kiaha which a Pima was supplying with a new rim stick. All wanted the kiaha painted and each suggested a different design, and clamorously insisted that her design be applied.

The three small centers of kiahas on Fig. 74 show the beginning of three different designs after the first few rounds of lace coiling have been passed. Fig. 74a is the simplest, but even here a series of short openwork lines furnishes a neat design; Fig. 74b is a more elaborate one which to this point consists of alternate bands of the two lace coils; Fig. 74c presents a design which radiates with already quite a bit of the evolving pattern to be seen.

The simplest kiaha design represented is Fig. 78b, where the lace covering is broken by four vertical shafts extending from the apex to the rim, thus dividing it into four sections. The shafts taper toward the top from a beginning of eleven plain loopings at the base to four loops at the rim.

They are edged on either side by a band of twisted lace coil, a second band of the plain coil, and a third of the twisted coil, and these three continue across the apex to form four large triangular spaces between the shafts. These triangular quarter sections are crossed by three rows of smaller triangles of plain lace coil, outlined by the twisted coil. Color is introduced on the open bands which outline the quarter sections, first red and then blue; and on the horizontal bands which divide the rows of small triangles by red, blue, and then red; and on the oblique of the smaller triangles blue and then red. A child's kiaha of similar pattern, but much simpler, shows two circling bands of triangles without the dividing shafts, with the lower triangles edged with blue and the upper triangles with red.

Slightly more complicated is the pattern of Fig. 78a, where the four shafts as before divide the lace cover. These are edged with six alternating bands of the plain and twisted lace coil which continue across the apex to form the quarter sections, although here not of triangular shape as before, but quadrilateral with a short base line and a longer top. Within this quadrilateral extend oblique bands of alternating plain and twisted coil so painted in a very dark blue and red as to distribute the colors evenly over this chaste but effective design.

A simple design is represented by Fig. 75b, where the short broadly tapering shafts continue but part way up the covering and are outlined by the two varieties of lace coil in such a manner as to move in zigzag pattern about the kiaha. A shorter shaft is dropped from the rim to fill in the space left vacant by the dip of the zigzag, while color is introduced in the usual alternating lines thus accenting the zigzags.

Another pleasing design, illustrated in Fig. 77b, also has shafts that do not continue to the rim, with the same manner of outlining them as well, and in these remind slightly of the last kiaha pattern. The shafts, however, are slender and remain of uniform width their entire length. Between them are grouped parallel horizontal bands of the two lace coils, with a short dip at either end. Color added in alternating red and blue bands completes this well balanced design.

Figs. 75a and 76a are quite similar in design, but differ in the closeness of texture since Fig. 75a is a better made lace coiling. The two halves of the design within the quarter section balance, for the shaft dropped from the rim in spear shape is so outlined as to produce forms quite like the old-fashioned sawhorse, whose open bands are painted alternately blue and red.

Fig. 76b is also a balanced design and planned on somewhat similar lines to the last two, for the dropped arrow-shaped shafts extending from the rim are outlined by alternating bands of the two lace coils, but so as to form a different figure with a medallion center in appearance, which in reality, however, is a fret motif.

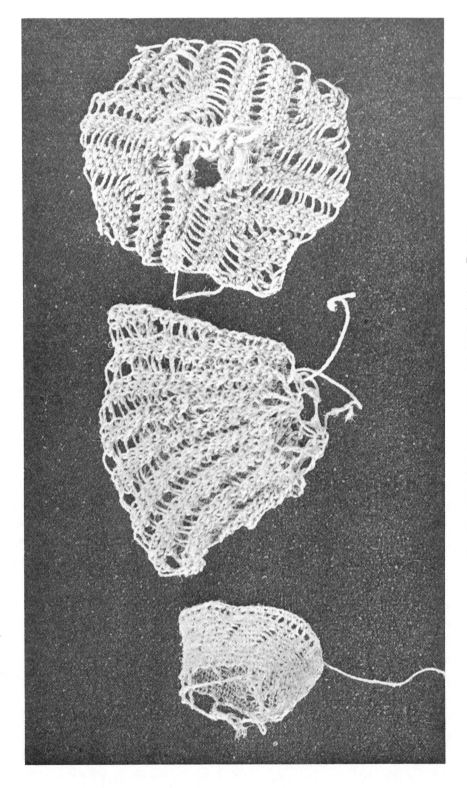

Fig. 74 (50.1–5150, 5151, 5237). Kiaha Beginnings, Papago.

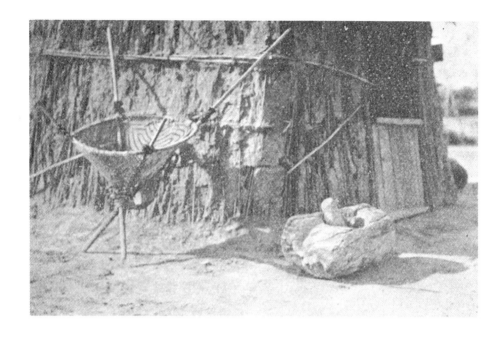

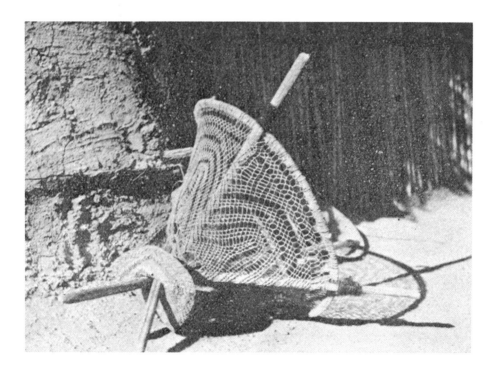

Fig. 75. Kiahas, Papago.

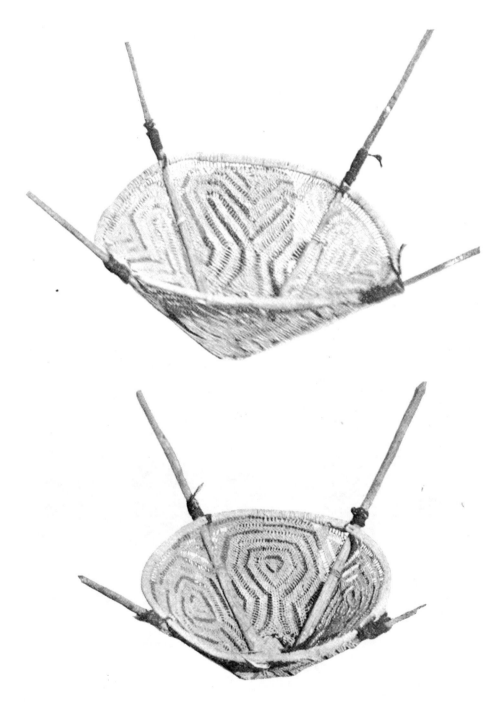

Fig. 76. Kiahas, Papago.

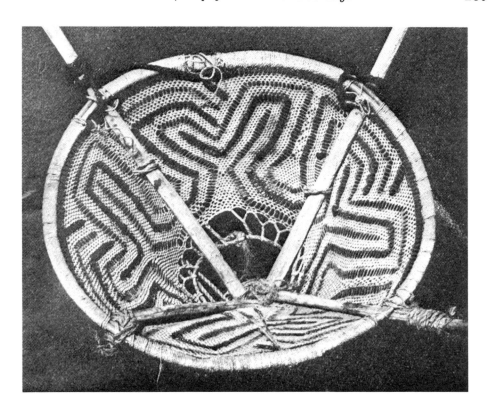

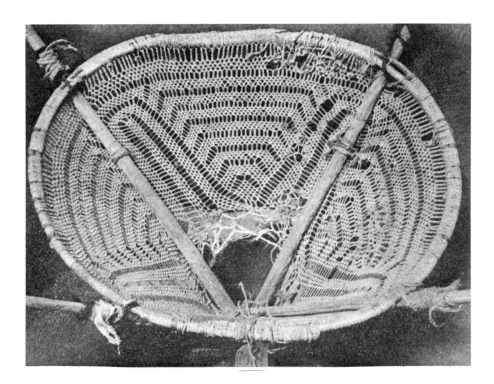

Fig. 77 (50.1-4645, 5326). Kiahas, Papago.

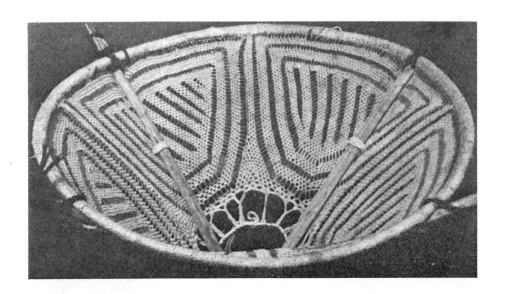

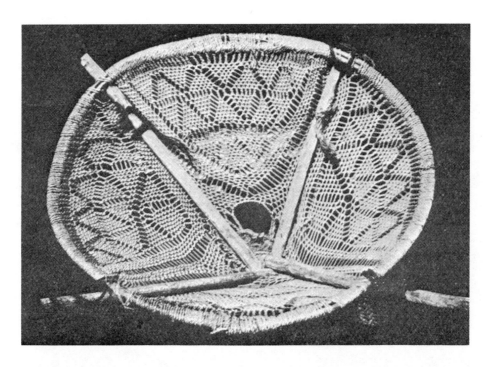

Fig. 78 (50.1–5319, 4529a). Kiahas.

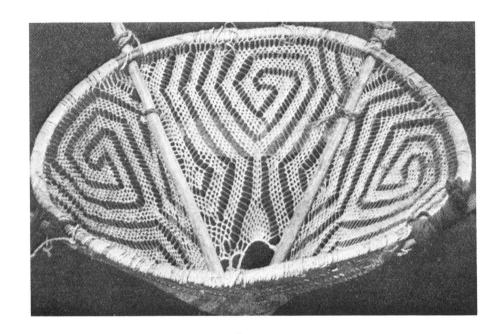

a

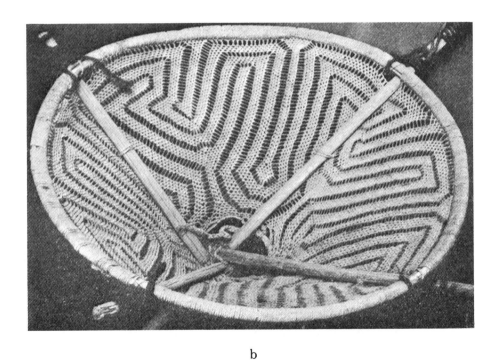

b

Fig. 79 (50.1–5333, 5320). Kiahas: *a*, Papago; *b*, Pima.

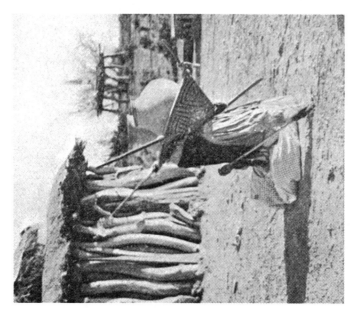

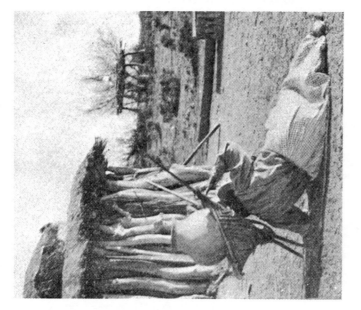

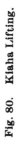

Fig. 80. Kiaha Lifting.

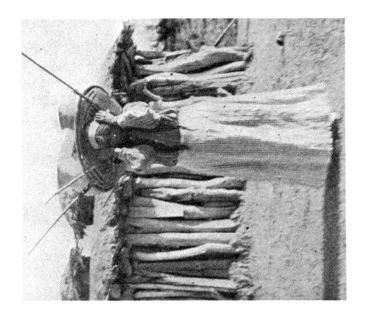

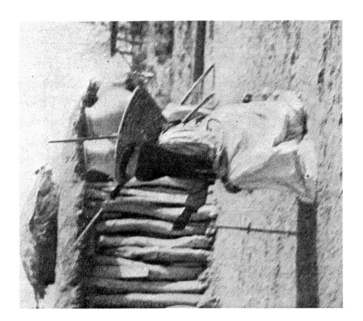

Fig. 81. Kiaha Lifting.

Another seemingly balanced design is that of Fig. 77a with the outlining bands of the shaft so turning and winding as to form a slightly similar design to Fig. 76a, although not so carefully and effectively planned or executed. In reality, it is constructed of eight meandering double lines of the two lace coils, four short ones which pass over a quarter of the circumference, and four long ones which cover half of the circumference. These, with an added short oblique dropped from the rim circle, complete the design.

A closer meander, but not one of broken bands like the last, is the design in Fig. 79a, b, constructed of three continuous double bands, three close bands of plain lace coil with three accompanying openwork bands of twisted coil, which outline the long shaft extending from the rim before doubling upon themselves to form a triangular fret. Color is added to these last two designs in the usual manner.

EVOLUTION OF TECHNICS.

Many ethnologists claim that basketry was one of the earliest arts among primitive peoples, since grasses, roots, and twigs could be easily interlaced and twined into simple receptacles. As to the age of the art among the Papago and Pima nothing definite was gleaned, either of the simpler and what appear to be the older types of basketry, or the more complicated. That "basketry was introduced among the Pima one hundred years ago by the Maricopa" is the statement Mason makes in 1902, in reference to the coiled basketry of the Pima.[1] Other reports from old settlers in the Papago villages of the Quijotoa Mountains and the Santa Rosa Valley, the very heart of the present day coiled basketry industry, state that very excellent baskets were made twenty-five years ago, but fewer baskets than now, since at that time they were constructed for Papago use only and not for sale, while now popular demand has resulted in an active trade in them. The Papago coiled ware of twenty-five years ago was more carefully made than that today, since much of it was water-tight, at times serving as basket buckets for drawing water from the well, and as vessels for watering stock. Even up to the last few years basket bowls for watering horses on the journey, were strapped to the saddle and these, together with the older long bottle-shaped basket olla, used in pairs, hung from either side of the horse, made journeying on the desert less dangerous. The custom of burning at death the belongings of the deceased, has deprived the world of many Papago and Pima baskets. Good luck favored at this time the find-

[1] Mason, O. T., "Aboriginal American Basketry" *Nat Mus. Rept.*, 1902, 519.

ing of one old basket, for by mere chance a discarded bowl much the worse for wear, was discovered resting on a refuse heap back of an Indian hut in Quijotoa. On the morning when this old fragment was rescued from the rubbish heap, the prize of the expedition was secured, for it had been made by a woman long gone, whose great, great grandchildren, aged three and five, were sitting before the hut together with relatives of three other generations of the basket maker, the oldest member of the group being a very aged woman. From this old basket we know exactly what degree of perfection the art of coiling had reached at the time it was made, and it records the stage of coiled basketry five generations ago, both as to technic and design. The art at that time was advanced, for it had indeed reached a high degree of perfection and elaboration (Fig. 61). The technic is even and water-tight as attested by the stitches near the edge of the rim for securing the leather thong by which it was suspended from the saddle, announcing that this aged bowl did service on journeys for the holding of water. The design is a two band fret of complicated pattern, and as handsome a Papago design as the writer has ever seen.

One point of interest connected with the age of coiled basketry is brought up by the small plaited center or beginning. Coiled ware of most tribes is begun by bunching together a bit of basket material, and turning it to make a small ring, and then binding it, and the coiling worked into this ring. Here the small center is plaited, which raises the question, Is this the result of plaiting being the older technic, and was this small plaited center borrowed from the earlier technic?

Leaving the age of the different Papago-Pima basketry technics, until further information gives more light on the subject, we will pass to a discussion on the possible evolution of two technics in the area, which to all appearances have passed from a simpler to a more complex form. It is unnecessary at this time, to expand upon the wonderful inventive faculty possessed by man of lower culture, as displayed in the development of his handiwork. That has already been vividly pictured in the introductory chapter of "Origins of Invention."[1] Nevertheless, with each new instance of his skill and creative power, one marvels anew, and so here, one wonders not only at the surprising dexterity of these Indian women, but also at their mental activity in thinking out these technics, for which they need, what they seem to possess,— well-developed perceptive faculties and a remarkable "scholarship of the senses." Two technics in the region are found in two successive stages, lattice wrapped weave and foundation coil, that appear to connect up in a varying series either of progression or retrogression,

[1] Mason, O. T., "Origins of Invention."

although no positive proof has been found that they have evolved, or declined here.

The simplest, and in all probability the earliest technic in the region is wrapped weaving, a basketry construction very near to fundamental needs, when wants were primitive and the demand for objects to assist in the protection and storage of foods, etc., was paramount (see p. 140). Only remnants of this old basket technic are now to be found, as the crude wrapping of a pliable binding element over stiff slats, arranged in parallels, has almost entirely disappeared but a few old doors for huts and storage; houses, crude cages for live birds and small animals, hanging shelves for preserving food from marauding beasts, and cradles for the infant, are still to be seen in the out-of-the-way villages, where people have held to this early mode of construction. Wrapped weaving seems the simplest way of uniting stiff slat-like strips by means of a soft pliable binding element, and the impossibility of constructing wicker and twined weaving with these materials (see p. 134) must naturally have led these people to this third type of weaving for heavy structures, since nothing but wrapping could be done to unite the unwieldy material at hand. This is accomplished by one of two methods, a plain wrapping, and a latticed wrapping, giving two varieties of the technic in this region, both of which, however, are becoming extinct (Figs. 1–10).

The crudest form of the simple variety constructs the native hair brush (Fig. 8), an article common to many American tribes and made of numerous materials including roots, stems, and leaves of various plants which are tied, knotted, or woven together in a number of technics with a binding element of fiber, fiber cord, or just a strip of cloth, or leather. The technic here is most elementary, merely wrapping and then fastening a bunch of grass, roots, or fiber, at times roughly, at others, more skilfully. A step in advance is the more perfect wrapping found on larger forms, such as doors and sieves, where the technic has developed and taken such form as to be dignified as basketry wrapped weave, since the rods, or slats, act as separate warp elements, laid in a parallel series, and wrapped singly by the binding element, or weft (Fig. 1).

Moving on from the simple wrapped weaving to a second technic, which apparently is found here in two stages of development, we come to a more elaborate type, lattice wrapped weaving (see p. 141), which exhibits an interesting advance, ostensibly conceived through the uniting of the principles involved in simple wrapped weave and in a crude knotting employed over latticed elements in house construction. The walls of Papago and Pima grass huts are built of a parallel series of rods, or stems, placed vertically and crossed at right angles by horizontal parallels placed both on the outside

and inside at short distances apart. These are tied or knotted together at intervals by a fresh young willow twig while green and with its leaves still on, or by a leaf of the Spanish bayonet beaten slightly to soften it, that it may be more pliable and tie easily (Fig. 9). Lattice wrapped weaving adopts the latticed elements of house construction, and the uniting agent of wrapped weave.

The second technic which appears to have evolved in the region is foundation coiling, represented in two different stages by two distinct coils, an undeveloped variety (Figs. 27, 28), and a fully developed one (Figs. 34, 59–66). Foundation coil in its simplest stage is so rough in appearance that one wonders what this brush-like structure can be, as it seems but a tangle of stems which might possibly have grown so (Fig. 27). But this mass of twigs with so unprepossessing an aspect has a definite method of construction which forms a crude coiled ware, the simplest basket work coiling now known (see p. 172). The technic is most elementary, for it is built of one element which supplies the functions of the two elements in fully developed foundation coil, a foundation and a binder. It is unique how the serving of two distinct functions is accomplished by the one element composed of separate twigs, which, however, does not construct a strong, or a durable structure, but one which must be made new each year. It could not possibly be strong as there is no true foundation, and the single element is also engaged in the uniting process; neither is there a true binding element as it must serve also as a supporting layer; and also it is only loosely secured by the two extremities of the twig, the stem end and the leaf end which twist about the last twig of the round in process, without entering the previous round other than a loose thrust into it. Still, it is astonishing how well the basket granary which it builds hangs together even for a year of service. Its one element, like all coiled ware, moves in a continuous spiral from base to rim, but unlike other coil it has its double function to perform, that of acting as a foundation, and also as a binder in uniting its own adjacent rounds, and as has been shown, it does this uniting in the unique manner just described.

A decided step in advance in foundation coiling, is its second stage of evolution, for fully developed coil is composed of two distinct elements with separate functions: a foundation with a duty of its own in furnishing the groundwork, and a binding element with work of its own to perform in joining together the groundwork. Fully developed coil, like crude coil, is built in a continuous spiral with its adjacent rounds, or segments, united into a solid surface; but in contrast its two elements work separately, although jointly, and so form a firmer, smoother, closer, and more durable structure (Figs. 34–35, 59–66), than did coiling of one element. Foundation

coil of two elements is seen in this region in two degrees of finish: in a coarse open technic on granaries (see p. 179), and in a more refined and closer technic on trays and bowls (see p. 179). Both Papago and Pima construct their technics in the easiest and most natural way, crude coiling of one element clockwise, and coiling of two elements counter-clockwise, when due consideration is given as to the side desired for the outer, or smooth surface, which with the general run of bowls is the outside, and with trays, the inside. A seeming exception to the counter-clockwise movement of foundation coil when building large coarse granaries as seen in Fig. 39, is cleared up by noting that the basket is entirely worked from the inside.

The natural order of growth has been assumed in this description, an orderly progression in the "unfolding of the arts of life" as one would naturally expect, from the simple to the complex, the crude to the more refined. It seems normal to assume this, and there is no reason now known why crude coiling should not have found early expression among the villages in the vicinity of the streams along which arrowbush grows, or that this early form of crude coiling might not later have led to the highly specialized, perfected coil. Neither is there any ground to dispute why crude wrapping, such as we now find on hair brushes and knotting on house structures, should not precede the more highly developed wrapped weave and lattice wrapped weave. Still it is quite possible that the perfected technics were present first, and that instead of successive stages of advance, that there were successive steps not of deterioration, but of simplification of methods to fit certain needs. To instance, crude coil may have appeared late among the Pima, in response to a need for large granaries in which to store the crops when there was not present sufficient pliable material for foundation coil of two elements, and that this led to a further search for material and the discovery that twigs of arrowbush could be used in this way. No matter what its origin may be, the fact that it has survived to this day, side by side with a more perfect coiling is partly due, no doubt, to its great practical value as a speedily constructed technic of great use.

A further change has come to the coiled basketry of these tribes which must be recorded, a gradual modification effected by the arrival of civilization, which destines that in the near future there will be a widespread knowledge of a different style of coiled basketry from that which has been described in this report. It has already wrought many diversifications, for civilization is fast changing Indian customs, and old methods are fast disappearing, so that these innovations which are incidents in the history of culture must receive attention. In response to new conditions and the call for baskets to suit the needs of civilized man, the Pima have furnished many new shapes

large and small, foreign to the Indian, and the market is flooded with waste-paper baskets, sewing-baskets and many others whose design is treated above (p. 224). The Papago have also responded to the call, but not as the Pima, for their limited supply of material would not permit it. Their problem was not alone that of furnishing new shapes, but of finding a new basket material. Yucca has supplied the need, so that curio shops are full of Papago baskets of yucca, mostly small and of numerous shapes.

DIFFERENCES BETWEEN PAPAGO AND PIMA COILED BASKETRY.

Distinctive differences between the coiled basketry of the linguistically related Pima and Papago tribes has not to my knowledge been previously noted, or if so, there is no record of such in print. The terms "Pima basketry," and "Papago basketry," seem to be used interchangeably by most anthropologists and collectors, as covering one group of coiled ware with the conventional black fret designs. Even in our museums it is not unusual to find cases bearing the label "Pima and Papago basketry," in which are assembled indiscriminately, coiled ware from both tribes. In many instances these cases contain few if any Papago baskets, since collectors have secured their material from small dealers, who do not know the Papago basket, or if they have obtained them on a "from hut to hut canvas" among Papago villages, they have neglected to inquire as to the maker of each basket, else they would have detected that side by side in these huts is coiled ware from both tribes. That this should have escaped the investigator is not strange, since a hasty inspection would not reveal that desert conditions had been agents of Indian trade, and that an extensive traffic had brought many Pima basket trays and bowls to the Papago, who style them "baskets from the other country." Scarcity of basket material for making their own coiled ware demanded trading either in the raw material, or the finished basket and in many cases the last was found preferable. When this mingling of coiled ware from both tribes was first perceived in Papagueria, and when it was noted that a distinct designation, "baskets from the other country," was given to Pima baskets, a careful study was immediately begun of all coiled ware in use in and about the Papago huts, with special reference to differences which might exist. A diversity proved to be the case, for a marked differentiation was found between the baskets of the two tribes. The discovery of a variance remained for an intensive study of their textile arts, research which showed without a doubt, that the coiled basketry of each tribe has distinguishing characteristics, each a distinct place of its own among that of other basket-making peoples of lower

culture. These facts of difference which were obtained with persevering inquiry are the subject of this chapter, but their discussion will exclude the newer baskets made for sale (see p. 224).

Coiling is the basketry technic by which these people are known, for "Pima and Papago basketry" means to the world their light colored trays and bowls with the black fret designs. That coiling should be thus singled out to receive this distinction is not strange since it is their most elaborate technic. The quality of the materials employed in its manufacture; their painstaking gathering and preparation; the fineness, closeness, and perfection of workmanship in its construction receive only just recognition in giving this technic first place in their basketry. So it is the technic best suited to be chosen by these people upon which to devote their leisure time in perfecting and decorating. It was a technic upon which to impress individuality; hence, the importance of the difference in Papago and Pima coiled basketry as a possible factor in the cultural differentiation of these tribes.

To fully appreciate certain qualities in the Papago and Pima coiled ware a hasty survey of the two habitats (p. 127) will be helpful, since environment is one factor, and a strong one, in occasioning dissimilarity (p. 139). The Papago in their foothill villages are surrounded by a harsh, dry, spiny vegetation which has made use of innumerable means for preserving moisture, enlarging stems and leaves for the storage of water, coating the plant surface, and shrinking leaves to small size, to spines, and to nothingness to prevent evaporation, all to little avail, since plant life has so slight an amount of moisture and flexibility that but one suitable binding material for coiled ware is present, the black martynia. The Pima along the few desert streams which furnish a scattering of willow and cottonwood, use these materials for their coiled ware in preference to martynia which also grows in the region, since splints from the willow and cottonwood twigs are more easily prepared than are splints from martynia pod-hooks. So the Pima make a basket of willow or cottonwood, only using martynia for the design while the Papago very frequently make a basket of martynia with willow design. When the basket is of willow, the design is woven in an exceptionally heavy pattern of martynia. The relation to the environment is here felt since the supply of martynia gives Papago baskets a dominance of dark over light, as the Papago with a minor exception, must procure their binding material from elsewhere; while the supply of willow and cottonwood give Pima baskets a dominance of light over dark for the reason given above (see p. 139). Another difference partially dependent upon environment is that of build, which results from a diversity in foundation materials: the Papago have the harsh beargrass which builds a stiff unyielding structure, but one

of great durability, because of the strength of beargrass; the Pima are provided with the softer cat-tail which builds a more pliable, but less durable basket (see pp. 139 and 195).

Aside from dissimilarity in dark and light, and in qualities of build which seem dependent upon environmental influences, the coiled ware of the tribes shows marked variance in shape, as discerned in the outlines of Papago bowls and trays in Fig. 44 and those of the Pima in the same figure. The bowls differ most conspicuously as the Papago take on a more or less globular shape; the forms are broader in proportion, that is, their width exceeds their height to a greater degree than the Pima; the wall is more nearly perpendicular without the great spread of the Pima; the base is broad and flat; the outline curves rounding, all adding to the general substantial appearance (Figs. 44, 59a, d). Pima bowls are more bell-shaped; the forms of greater height and more slender proportion; the walls more oblique, the rim extending far out beyond the supporting base; the base small and rounding; and the outline curves oval and upspringing (Figs. 44, 63a, and 65d). The trays show the same contrast as to form, but in a less degree, since the low tray form restricts variation. Papago trays when compared with Pima are slightly deeper in proportion to width, the slant of the wall, although oblique, is at a narrower angle owing to the broader, flatter base, while the outline is less likely to be in double curves (Fig. 44).

Could we handle these baskets we would find diverse qualities in build not yet accounted for. Papago ware, especially the bowls, is thicker in wall (Figs. 59b and 65c), more firm and hard, owing to a tighter drawing of the binding element (Fig. 59b), and more irregular in the segments of the binder (Figs. 59a and 61), than are the coiled baskets of the Pima whose walls are thinner (Fig. 65a) and more smooth and even (Figs. 63 and 65).

Comparing the coiled ware of the two tribes for aesthetic differences one is first impressed by the strong feeling for large masses of dark and light on Papago baskets (Figs. 59a, b, d, f, 62c, 64a, b), and a feeling for line on the Pima, which is expressed in a network of black. The massing of dark and light on the Papago ware is produced in a number of ways: by the grouping of lines as in Figs. 59b, c, d, e; or by a greater width of the design line as in Figs. 59f, 61, 64a, b; or by dark spottings as in Figs. 59b, d, 62c, and 65c. The thin line tracery on the Pima baskets is effected by the use of narrower and more elaborate design lines than commonly found on Papago baskets, as seen in Figs. 63 and 66d, e, f, and when spottings occur as in Figs. 60c, 63, 64d, and 65d, e, f, they are smaller, adding a dramatic note to the pattern as the bits of dark sparkle amidst the intricate traceries, quite in contrast to the more dignified massing of darks by the Papago. A second impression received from these baskets is that the Papago deals mostly

with horizontal line which give a restful stable quality to the design (Fig. 59). While it is true the Pima uses the horizontal line it is only in a secondary way, for it is held in subservience to a more dominant motif, an active one, the spiral, or the whorl (Figs. 63 and 65). Even many of the rosette patterns, which appear to lack the active note as they are not spirally built, have a strong feeling of motion caused by a breaking by oblique lines (Fig. 66e, f).

On searching for differences as exhibited in pattern we find the Papago have a number of distinct types including the following: the encircling fret (Figs. 61 and 64a, b); the horizontal band in several arrangements (Figs. 59 and 62b, c); and the vertical fret (Fig. 60a, b). The Pima also have a number of types including: the fret which is quite unlike that of the Papago (Figs. 60c and 64d, e); the rectangular whorl (Figs. 62d, e, f and 63a, b, c); the triangular whorl (Figs. 63d, e, f, 64d, 65a, b); the spiral (Figs. 60e, 64c, and 65d, e, f); and the rosette (Figs. 64f, 66). Still because pronounced differences have been found in the patterns of the tribes, it does not mean that it is always an easy matter to differentiate, since the designs of the two have become mingled and exchanged, and one finds Pima designs on Papago baskets and likewise Papago design on Pima baskets. Hence, it is frequently difficult to discriminate; still by taking the older baskets of each tribe and noting the exclusions, one gets a working basis upon which to build and also to weed out.

Following the distinct types of each tribe further, watching also the manner in which the two differences, light and dark, and line activity evolve, let us scrutinize more particularly, first examples of Papago design and then of Pima. In addition to Papago plain black baskets, which are mostly bowls, and are still found in the outlying districts, are black bowls with the simplest form of Papago design, broken bands arranged in parallel horizontals (Fig. 59a). These parallel series of horizontals may be connected with parallel obliques as in Fig. 59d, a design which shows considerable variance both in the length of the horizontals and in the length and width of the obliques, but in almost every case, as here, the black overbalances the light. A third arrangement of parallel horizontals and a vertical grouping, as was the last, is connected by parallel verticals, whose uniting may form the more usual simple rectangular zigzag of Fig. 59b, or the less usual enclosed rectangular shape of Fig. 65c. In the first case the lines of the design are frequently of varying widths as in Fig. 59b, in the second, they are more usually of the same widths; but in almost every instance the design is light on a dark ground. A fourth vertical grouping of parallel horizontals is united into separate clusters by means of small triangles (Fig. 59e, f). This design possibly is not Papago as it differs in many ways from other

designs of the tribe, but I am not prepared to say it is Pima. A fifth variation in this grouping of parallel horizontals or, in reality a variation of the third grouping (Fig. 62b, c), with rectangular spottings introduced at the union of the perpendicular elements, suggesting Pima influence (Fig. 66c), and another grouping of these same lines and rectangles gives the pattern found in Fig. 66b. One of the most interesting Papago designs is the vertical fret (Fig. 60a), seen here in its simplest form. The different variations of this motif suggest a play with the long unbroken serpentine line as it doubles and quadruples upon itself in its more elaborate varieties, although it never crosses itself and keeps a line of uniform width throughout, together with one of equal spacing. Here the design is fivefold, elaborate arrangements are more usually fourfold.

Of Pima pattern the fret is probably the oldest and most common design. This motif used alone, is indifferently represented in the Museum collection, since fewer of this design are now to be found, but the student who wishes further study is referred to the 26th Report of the Bureau of American Ethnology, where material is illustrated which was collected at an earlier date when more typical Pima fret designs were to be had. The fret when unaccompanied by other design units is found in encircling bands, simple and elaborate, and in spiral arrangements. It also finds endless employment in union with other units of design, the rectangular and triangular whorl, the spiral and the cross, in single, double, and triple bands. These bands may be uniform in width (Fig. 60d), or uneven (Fig. 63b), spotted at their turning with rectangular shapes (Fig. 60c), interrupted at points of intersection by crosses (Fig. 64d, e), and decorated with the terrace (Fig. 63a, b, c, e, f). The whorl, one of their most used patterns, consists of four central twirling rectangular arms with generally a repeating whorl of four rectangles at the rim (Fig. 62d). The arms vary in length and width, and the shape seldom holds to a true rectangle, but increases in width toward the rim in addition to the variation caused by the swing of the whorl (Figs. 62e, 63a). In the intervening space between the whorls is a fret of two or three bands whose lines are sometimes uniform in width (62d) but often of wider horizontals and lighter obliques (Fig. 63b). The obliques are quite frequently composed of a line of small triangles, forming what is called the "terrace" design. The points of the triangles of the terrace may turn toward the swing of the whorl, or away from it. The triangular whorl, another much-used Pima pattern, consists of three, four, or five twirling triangular arms extending from the base, with a repeating number of triangular forms extending from the rim (Figs. 63f and 65a, b), but here the forms at the rim may hold to the size of those at the center (Fig. 63f), or be much enlarged (Fig. 65a, b). These rim shapes at times may repre-

sent the seed pod of the martynia (Fig. 65a, b) when the design unit is called "martynia." The proportions and the contour of the center triangular whorls vary even more than the rectangular whorls while the intervening fret takes on a multitude of variations from the very simple (Fig. 63f) to the very elaborate (Figs. 63e and 65a, b). The lines composing the bands of frets may vary in width as in Fig. 63e, or be more uniform as in Fig. 63f, while their obliques may be plain or terraced (Fig. 65a and 63e, f). The spiral design of the Pima may be constructed of a number of simple zigzags composed of two elements, a long horizontal and a short vertical or oblique (Fig. 60f), which here is on a Papago bowl, but generally the spiral is decorated at the steps of the zigzag by some small unit of design (Fig. 60e), frequently one or two small squares (Fig. 65d, e, f). The spiral is also combined with the scroll (Fig. 64c). Another Pima pattern and one which is generally thought to be recent is the rosette which appears in several varieties, two of which are seen here, a more floral form (Fig. 66e, f) and one composed of rectangular zigzags and black rectangular spottings (Fig. 66a, b, c). One of the very oldest patterns of this tribe suggests, to a slight degree, a rosette, but more carefully described, it is a maltese cross and hourglass pattern (Fig. 64f). Another very old basket with similar pattern is in the National Museum. The design is so different from others of the Pima that it is to be hoped further research concerning it will be undertaken.

Summing up differences in the pattern of the tribes we find that Papago design is dignified and reserved, while the Pima is full of action and grace; that in handling the Papago is simple, strong, direct whereas the Pima is elaborate, delicate, intricate; that in appearance the Papago design shows a feeling for large masses of dark and light, but the Pima a feeling for line expressed in a network of pattern with small spottings in black; that in technic the Papago make a crude irregular line, while the Pima line is clearcut and perfect in craftsmanship. In units of design both tribes have the encircling fret but handled in two entirely distinct manners, the Papago have the broken horizontal band effects and the vertical fret while the Pima have the rectangular and triangular whorls, the spiral, and the rosette. Thus the pattern of the two tribes differs in movement, treatment, aspect, technical skill, and design motifs. These dissimilarities in design, together with those of material, build, proportion, contour, finish, and dark and light, obviously give distinct Papago and Pima coiled basketry.

Tabulated Analysis of Designs.

The following description of figures illustrating coiled basketry, is arranged in the order suggested by the preceding study that it may assist further research in the subject. The designs grouped under Papago baskets are undoubtedly Papago, or in exceptional cases more Papago than Pima. The designs grouped under Pima baskets are likewise either undoubtedly Pima, or more Pima than Papago.

Papago Baskets.

Fig. 59a. A design of wide broken bands arranged horizontally on a black ground. A typical Papago design on a rounding bowl of substantial water-tight structure, said to be one hundred years old, from the Santa Rosa region. Entire black baskets frequently take this shape.

Fig. 59d. A second vertical grouping of parallel horizontals connected by parallel obliques on a black ground, design fourfold. A very old globular-shaped bowl of hard water-tight construction from the Santa Rosa region.

Fig. 59b. A third vertical grouping of parallel horizontals united by parallel verticals, on black ground. The design lines in this old pattern are typically Papago in their unevenness and irregularity moving about the bowl in a fourfold rectangular zigzag. A very old water-tight, board-like structure from Brownell.

Fig. 59c. A similar design to the last but three-fold, newer and less interesting. A water-tight tray almost too perfect in workmanship for Papago, but its design and width of design bands place it here, from Santa Rosa.

Fig. 65c. A similar design to Fig. 59b except in the movement of the horizontals which do not flow, but enclose four rectangular shapes, between which are black areas filled with "coyote tracks." A globular shaped bowl from Santa Rosa.

Fig. 59f. A fourth grouping of parallel horizontals united by verticals composed of lines of small triangles in heavy black lines on a light ground, producing a six-fold rosette-like pattern on this well made, but much used old tray from San Xavier.

Fig. 59e. A design similar to the last but in narrower bands of pattern, arranged in a fourfold wheel-like figure on this old water-tight, hard as a board, deep tray with thong saddle attachment, its locality, Covered Wells.

Fig. 62c. A design of the third grouping of parallel horizontals united by parallel verticals similar to Fig. 59b, but the added rectangular spottings at the union of the parallels show Pima influence, although in shape and in amount of dark this very large handsome old bowl from Ankon is Papago.

Fig. 62b. A different arrangement of the design lines of the last plate, which however in manner of enclosing shapes suggests Fig. 62c, although the rectangular spottings show Pima influence, as does also the workmanship on this large well-made, perfectly shaped bowl from Cohatk. One of the interesting problems for later research is this small central design unit "coyote tracks" and the rectangular spottings at the union of the design lines, which may be Papago, or Pima.

Fig. 62a. An all over pattern of "coyote tracks" design arranged spirally and sixfold, which in manner of distribution in a stepped spiral, and in technical skill, as well as in the small black center suggest Pima, but in spacing, amount of dark and quality of handling suggest Papago, on this newer and little used tray, whose design is frequently called "turtle."

Fig. 60a. Another grouping of short parallel horizontals so united by shorter verticals as to form upright frets, in this case fivefold. A most interesting old pattern with a number of more complicated variations effected by doubling and redoubling upon itself the long unbroken line of this simple design. This very old tray is from San Xavier. When more elaborate the pattern is usually fourfold and receives various names, "Juice falling from the Saguara fruit," "Trail of deer in woods," and "Tattoo marks on woman's face."

Fig. 60b. A modification of the last design in a fourfold pattern of wider frets with rectangular spottings which suggest Pima influence, as does the unusual skill in the workmanship on this newer tray from Quijotoa.

Fig. 64b. A splendid example of Papago treatment of the encircling fret in the simple direct handling of broad irregular design lines repeated nine times in the single band of white pattern on a black ground, as seen in this old dough tray.

Fig. 64a. An equally typical example of the Papago fret in two banded pattern with broad crudely irregular and unaccented design lines, fivefold on the inner band and eightfold on the outer, in black on a light ground.

Fig. 61. A superlative example of an elaborate Papago fret in two bands, whose broad uneven black design lines follow a complicated fret pattern, fivefold on the inner band and ninefold on the outer. A fragment five generations old, illustrating the degree of excellence to which Papago basketry had attained in design and workmanship through this old water-tight structure with its remnants of a thong suspension strap attached to this aged bowl from Quijotoa.

Fig. 60f. A pattern of seven black zigzags arranged spirally, quite possibly Pima in design when compared to *e* of this plate, a small hard, water-tight food tray of the medicineman of Santa Rosa, who eats and drinks from it when performing ceremonies or on trips for the sacred salt.

Fig. 63d. A Pima design with Papago handling in spacing and the crude irregular design lines, which form a fourfold pattern, on a deep globular bowl from Santa Rosa, typically Papago in shape and build.

Fig. 66d. A borrowed design of interlacing ovals on a globular incurving rimmed bowl which in shape, in build, and in the attached suspension thong is Papago, on a basket from Covered Wells.

PIMA BASKETS.

Fig. 60c. A fret design in two separate bands, accented at the turn by rectangular spottings, the wide inner band sixfold, the narrower outer band elevenfold, on a small well-worn tray from Cassa Blanco.

Fig. 60d. A fret design in one band with three connecting frets joined by a series of short verticals, on a small tray whose workmanship appears more like that of the Papago.

Fig. 64e. A fret, terrace and cross design in one band, with two interlacing frets, whose obliques are terraced, and whose points of intersection are combined with two small rectangular shapes to form a cross.

Fig. 64d. A fret, cross, and triangular whorl design in fourfold pattern with the three band fret interrupted by a double cross.

Fig. 62d. A simple rectangular whorl design in fourfold pattern, between whose four center arms and those of the rim run two intervening outlines forming a simple fret. One of the commonest Pima designs on this old well-worn tray from Cassa Blanco.

Fig. 62e. A more elaborate rectangular whorl design with four short central arms only, outlining which are four bands of simple fret, on a small shallow tray purchased at Santa Rosa.

Fig. 62f. A more elaborate rectangular whorl and "terrace" design, with four prominent center arms, repeated by four at the rim, between which run three bands of simple fret, whose oblique lines are edged on the inner side with small triangles, whose points turn with the swing of the whorl, the design termed "terrace." An old well-worn deep tray from Blackwater.

Fig. 63a. Another rectangular whorl and "terrace" design with the four long arms at the center and those at the rim joined to the two outlining frets, whose oblique lines are composed of small triangles turning in opposite directions back to back, an unusual arrangement. A large perfectly shaped and well constructed bowl.

Fig. 63b. A slender rectangular whorl and "terrace" design, with four plain-edged center arms and four repeating rim arms edged on one side with triangles, while the two slender outlining bands of fret, thicker on the horizontals than on the obliques, are edged on the obliques by the terrace design, the points of whose triangles turn away from the swing of whorl. A fine large old shallow tray, yellow with age, from Sacaton Falls.

Fig. 63c. A heavier rectangular whorl and "terrace" design with the four center and rim arms joined to the two outlining frets whose obliques are small triangles with points turned away from the swing of the whorl. A large low tray, in good state of preservation, from Blackwater.

Fig. 63f. A triangular whorl and terrace design, here the triangular form replaces the rectangular, to whose four arms at center and rim are attached the horizontal bands of an elementary fret, with obliques composed of small triangles turned away from the swing of the whorl.

Fig. 63e. A complicated triangular whorl and terrace design, the ends of whose five center arms connect by means of an elaborate fret with five terraced figures extending from the rim, no doubt taking the place of the rim whorl, for from it extend the broad horizontals and delicate oblique lines of the fret, one of which is terraced. A large new well-made bowl.

Fig. 65a. A triangular whorl, fret, "terrace", and "coyote tracks" design of five simple arms at center and five at rim decorated with "coyote tracks," while two elaborate intervening frets, with oblique lines edged with triangles are so arranged as to form a figure of the martynia pod, giving the design the name "martynia." A valuable old tray, fine in workmanship, and one which has seen much service from Blackwater.

Fig. 65b. A similar design of the "martynia" but on a newer and coarser basket, which in technic suggests Papago work.

Fig. 64f. A maltese cross and hourglass pattern with four hourglass-shaped arms projecting from the center with four similar shapes indirectly suspended from rim, the two intervening zigzags follow the lines of the eight hourglass forms but with four breaks at the rim allowing four open paths half way down the wall. An exceptionally finely built very old bowl from Sacaton Flats.

Fig. 60e. A zigzag pattern in four spirals grouped with a small quadrilateral figure, composed of two vertical lines and a triangle, at each step of the spiral. A small tray from Blackwater.

Fig. 64c. A combined spiral and fret design which is eight-fold, each spiral supporting two frets in heavy horizontals and light obliques, with small triangular spottings.

Fig. 65d. A spiral pattern of double rectangles with connecting horizontals, in five stepped zigzags composed of two spirals each, interrupted by a group of two rectangles touching at diagonal corners. A deep old bowl yellow with age, much used but well preserved.

Fig. 65e. A pattern similar to the last, except in six stepped zigzags of three spirals each, interrupted by a group of two rectangles arranged in the letter Z, and placed more diagonally than the last, giving greater motion to design. A shallow old bowl in excellent condition.

Fig. 65f. A pattern similar to the last except in four stepped zigzags of four spirals each, arranged less diagonally. A newer tray shape. The last three designs are frequently termed "whirlwind."

Fig. 66a. One of a series of designs built on similar lines to the next two, and also upon those on the Papago bowl, Fig. 62c, here the shape of tray changes the vertical lines of bowl design to obliques and the interrupting squares nearest rim to wide oblongs. Large black center with four radiating arms, repeated at rim, and four encircling rectangular zigzags with verticals about three fourths the height of wall pattern, on this well-preserved old tray, yellow with age from Cassa Blanco, whose design is frequently called "squash blossom."

Fig. 66b. A similar design to the last but sixfold, the three encircling rectangular zigzags with verticals three-fourths the height of wall pattern, on this newer tray.

Fig. 66c. A similar design to the last two but sixfold, the five encircling rectangular zigzags, with short verticals one third the height of wall pattern, and interrupting squares which suggest the spiral bowl patterns on Fig. 65. Probably Papago make.

Fig. 66e. A design with six central radiating triangular shapes, re-echoed by twelve at rim, between five uniform outlining bands producing a flower-like appearance. A shallow, little-used bowl procured at Santa Rosa.

Fig. 66f. A design similar to the last, but fourfold, with a similar center and six outlining bands with heavy horizontals and lighter obliques producing a more elaborate rosette-like appearance. A shallow bowl, quite new, from Blackwater.

REFLECTION OF PERSONAL TRAITS.

The differences between Papago and Pima coiled basketry appear to tally with the traits of each tribe in a very singular manner. Significant as seemed the dependence of the basket technic upon the unusual vegetation of the region which has so curiously brought itself, through adaptation, into harmony with the arid environment; and the ingenuity of the Indian in the economic use of the scant resources at hand (see p. 139); of even greater interest and importance is the seeming reflection of physiological and psychological traits in their coiled ware. Thus suggesting that although

man's dependence upon natural resources is great, he can to a degree free himself from external relations, and so direct his activities as to express himself in his handiwork by adroit adaptation, and thus give it an impress of personality, in this case reflecting the traits of his tribe.

The Papago of the solitary foothills are a quiet, secretive, silent people. No visitor approaching their village hears laughter or loud talking, for the quiet of the solitude which has settled around their desert home has left its imprint upon the silent people. In this forbidding habitat, where conditions are so severe, one is not surprised to find a sedate, brave, persevering people, for the loneliness and severity of life in these scattered villages has called for courage, self-reliance, and fortitude to battle with adverse conditions.

In contrast to the characteristics of the Papago we find the Pima with quite a different personality, due in some degree, at least, to their less austere home surroundings along the few streams, and in environs which do not call forth the same strength and fortitude as demanded by Papagueria. So instead of the quiet, stable, character of the Papago, we find the Pima with a buoyant, joyous, social nature, and one which is most temperamental. The Pima are better known than the Papago, to the trader, the collector, the merchantman, and this has changed them greatly; still certain traits can never be altered or obliterated. In matters of neatness and cleanliness the Pima are far from thrifty as shown in the arrangement of hair and dress which indicate decidedly that they belong to an easygoing tribe. However, an artistic temperament seldom gives much thought to personal appearance, but if the negative side of this temperament is shown in Pima dress, its positive side finds vital expression in the expert craftsmanship and beauty of their handiwork.

Phenomenal as it appears, the steady, reserved, seldom-smiling Papago woman constructs the substantial, broad, flat-based, and at times crude form with thick, firm wall; while the light-hearted, temperamental, talkative Pima, living a social life makes the delicate, slender, lighter form with up-springing out-curving wall, of more artistic build and finish. But before discussing to what degree personal traits are responsible for these qualities, one must take cognizance of the fact that influence of personality is not the only controlling force to be accounted for. There are other agencies at work which have a decided effect upon this ware. Environment is one of the strongest of the forces, governing through supply, and lack of supply, the amount of dark and light on the baskets, as well as the degree of rigidity and pliability of build. Environment influences another quality, which came in response to certain needs demanded by the habitat; giving to one tribe a water-tight technic and excluding it from the other, and quite proba-

bly providing a water-holding shape to the one, and not granting it to the other. Function determines to a large degree items of shape and build, especially in bowls (see p. 191), as the broad flat base and globular form with incurving brim of the Papago bowl (Fig. 59a, d) is steadier and holds liquid better, a function not necessary to the small based, out-spreading walled bowl of the Pima (Figs. 63a and 65d); while the substantial build of the Papago has come no doubt in response to a need not found in the land of the Pima. So Papago baskets have an excess of dark, a greater rigidity, and frequently water-tight technic as well as a form suitable for liquids; while the Pima baskets have an excess of light, greater pliability, and not the technic and form fitted for the holding of liquids, because of the influence of environment.

Hence function and materials are strong competitors to the modifying agency of personality. Nevertheless, although much is due to these (see pp. 139 and 191), there are qualities of shape and build which cannot be attributed to these causes. The heavy, substantial, crude qualities of Papago baskets (Fig. 59) and the grace and beauty of those of the Pima (Figs. 63a and 65d), in all probability owe much to a divergence in the personal caliber of the tribes; to a stronger feeling for the fundamental things of life by the Papago, whose simplicity and strength emphasize qualities of utility in preference to beauty in outline or nicety of technical finish; and to a sensibility for the aesthetic by the Pima, whose artistic nature gives greater heed to subtleties of contour and perfection in craftsmanship. The quality of durability, that is the length of a basket's usefulness — its life — depends much upon material; nevertheless, a different handling of the binding element by the two tribes, a firm, tight drawing of the binder by the thrifty, painstaking Papago, and a slighter drawing of the same by the less strenuous Pima, attests no doubt to the effect of tribe modification. Many of the dominant differences in the coiled ware must be a personal expression of the temper and individuality of each tribe, since it is easily seen that it is the self-reliant, never-disturbed Papago woman, living within herself, who constructs not the delicate, light form, but the substantial broad, globular, and at times crude one, with firm, thick wall, while it is the buoyant, joyous Pima living an out-flowing life, who makes not the stout, solid structure, but the thin, less heavy form with up-springing, out-curving wall, of more artistic build and finish.

But it is in design where native powers dominate, although even here the environment is felt in the proportion of dark and light, a strong factor in design. Still to no influence of material or function can be traced the dominance of the horizontal line on the reposeful, stable, dignified Papago's basketry, or the dominance of the active line on the lively, buoyant, joyous

Pima's basketry; nor can a vestige of their control be seen in the heavy massing of large areas of dark and light, or in the simplicity and directness of Papago design; nor in the network of sparkling line, or the elaborateness of Pima design. For an explanation of these one must look elsewhere than to outside causes. Contrasting natural traits of these tribes are reflected in their coiled basketry.

Key to Basketry Technic.

This key to basketry technic is given that the methods of basketry construction and terminology given in the preceding sections of the paper, may be better understood. The necessity for uniformity in classification and terminology is appreciated, that confusion be avoided and the reader be enabled more easily to follow.

The classification recognizes three kinds of basketry, plaited, woven, and coiled ware, the division being based upon their construction or building process, as the elements plait, weave, and coil. The fundamental process of the three distinct technics is easily discerned upon slight examination.

Plaiting constructs a mat-like surface by means of active elements only, which move over and under each other in regular order. No passive foundation elements are incorporated, neither are new elements added after the completion of the base, as those already furnished continue to plait the body of the basket.

Weaving is known by its upright warps extending from base to upper edge, as the surface is constructed on these passive warps, crossed by an active binding element, or weft. Two types of weaving, checked and twilled wicker, are less easily recognized because of the equal size of the warp and weft, but even here the distinct weft element added at the base may be traced encircling the basket.

Coiling can easily be distinguished by the spiral movement of its elements. This consists either of an active element, or of a passive element bound down by an accompanying active element.

The key approaches Mason's classification nearest at types of weaving, although here there are differences. Mason entirely excludes plaiting as a basketry process, while his types of coiled ware are based upon the components of the internal element, the foundation. The composition of the inner element is the last consideration, and a later division than is shown here.

Basketry Technic.

I. Plaiting of Crossed Active Elements.
 A. Parallel elements in two directions.
 1. Over and under one................Checked Plaiting
 2. Over and under more than one.......Twilled Plaiting
 B. Parallel elements in more than two directions..............................Lattice Plaiting
II. Weaving of Active (weft) across Passive (warp) Elements.
 A. Parallel warps in one direction.
 1. Weft interlaced....................Wicker Weave
 a. Warps coarser than weft..........Wicker Weave
 b. Warps of same size as weft
 a'. Over and under one...........Checked Wicker Weave
 b'. Over and under more than one...Twilled Wicker Weave
 2. Weft twined.
 a. Weft of two strands.
 a' Over one warp.................Twine Weave
 b'. Over two warps...............Twilled Twine Weave
 b. Weft of three strands.
 a'. Plain weft...................Three-ply Twine Weave
 b'. Braided weft.................Braid Three-ply Twine Weave
 3. Weft wrapped.....................Wrapped Weave
 B. Parallel warps in more than one direction.
 1. Weft interlaced....................Lattice Wicker Weave
 2. Weft twined.
 a. Warps oblique....................Oblique Lattice Twine Weave
 b. Warps vertical and horizontal.......Vertical Lattice Twine Weave
 3. Weft wrapped.....................Lattice Wrapped Weave
III. Coiling of Active Element or of Active along Passive Element.
 A. Active element only.
 1. Binder (weft) spiral..................Lace Coil
 2. Binder twisting....................Twisted Lace Coil
 3. Binder interlacing..................Interlaced Lace Coil
 4. Binder knotting....................Knotted Lace Coil
 B. Joint active and passive element.
 1. Binding spirally....................Crude Coil
 C. Active and passive elements.
 1. Binder (weft) spiral................Foundation Coil
 2. Binder twisting....................Twisted Foundation Coil
 3. Binder interlacing..................Interlaced Foundation Coil
 4. Binder looping....................Looped Foundation Coil

Papago Terminology.

Agave, aholta
Agave leaf, aholt
Arrowbush, schamtum
Awl, auvich (owl)
Basket, whoha
Beans, mone
Beargrass, mau
Blueing, schatuch
Bottle, vaco
Brush, washi
 schoch
 gorwecot
Cat's claw, opot
Cotton, thawke
Cottonwood, oupa
Cradle, vol cŭt
Eagle feathers, ba och aoth
Feather, äoth
Greasewood, schĭ quoy
Gum on greasewood, o shop a gum
Hanging shelf, kochta
Headrings, hä co
Horsehair, cauveumoch
House, bitke (adobe)
 washăke (grass)
 muchăke (ocatillo)
Knife, vinum
Maguey fiber, schoch
Man, awtum (awl)
Martynia, ähōch
Mat, mine

Mat making, miuetha
Medicine basket, washä
Mesquite, que
Mesquite bark, quiolituc
Metate, māchāte
Needle, hoy abŭt
Ocatilla, mu och
Olla, hähä
Owl feather, chocut aoth
Palmea, omuch
Peppers, cōō colt
Pinole, chue; supi chue
Red dust, witch
Resting stick for kiaha, schalake
Rope twister, thadawin
Saddle bags, hocho
Saguaro, has che
Smaller grinding stone, velecot
Sotol, (*Yucca elata*), tach ou we
Spanish bayonet, hovich
Storage bin, vaschum
String, hy
 vechĭna (made of hay)
Turtle, comkchit
Turtle shell, comkchit ulituc
Willow, chirole
Willow bark, chrotolituc
Wheat, pelca
Wheat straw, pelecan wavok
Wood, cō ŏch
Woman, ofă

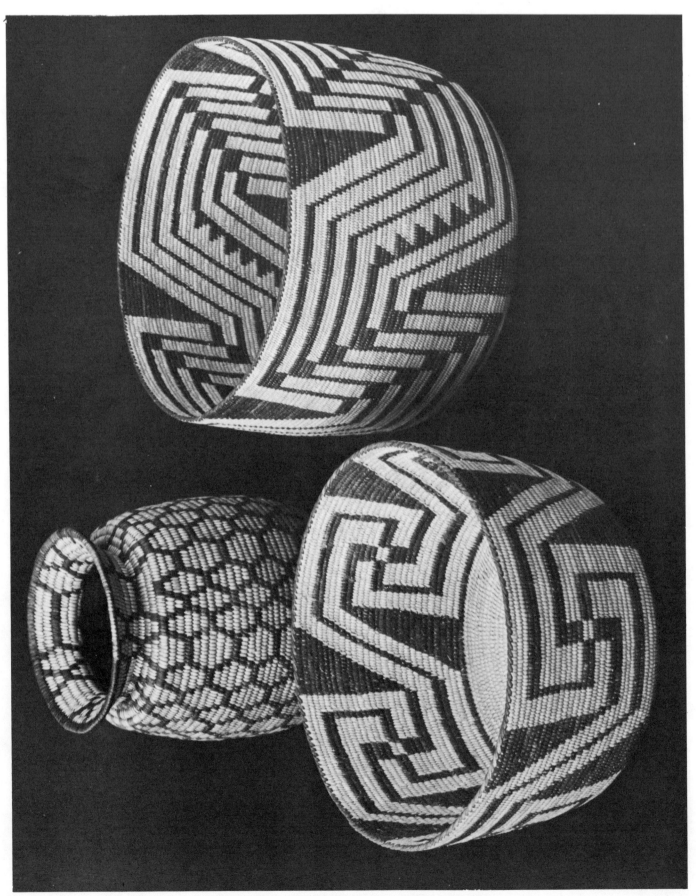

Pima baskets, deep bowl and jar shape types, illustrating a variety
of stitch-spacing, c. about middle 1930's. Heard Museum Collection,
photo courtesy Heard Museum.